I feel myself to be making my own journey, making a path of my own
Tony O'Malley

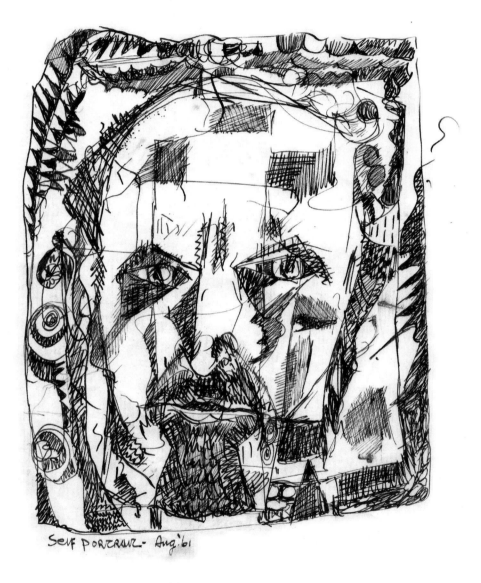

SELF PORTRAIT - Aug.'61

each day is a journey, the journey itself home

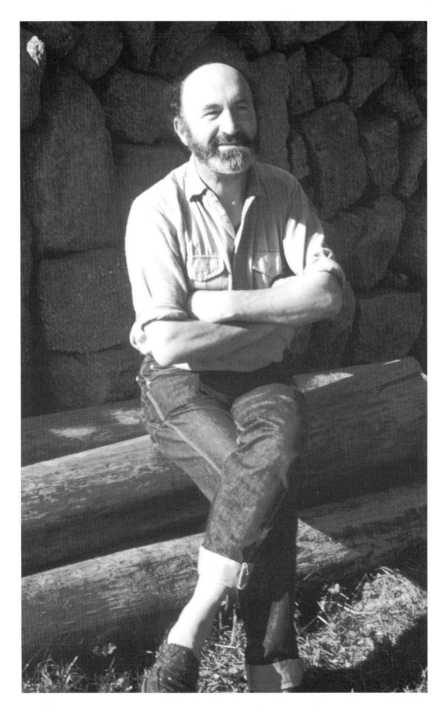

Tony O'Malley on St Martin's, 1964 [RS]

Footnotes on a Landscape – 3

Tony O'Malley
An Irish Artist in Cornwall

DAVID WHITTAKER

David Whittaker (signature)

wavestone
press

Dedicated to Dr Roger Slack and the memory of
Janet Slack (1920-2004) – *gentleness personified, kindness exemplified*

Tony O'Malley: An Irish Artist in Cornwall
ISBN: 0-9545194-3-4
Wavestone Press
6 Rochester Place, Charlbury, Oxon OX7 3SF, UK
Tel. 01608-811435
Email: wavestone@btinternet.com
Web: www.wavestonepress.co.uk
Text Copyright © David Whittaker 2005
Except *Inscape – Life and Landscape in Callan and County Kilkenny* © Willie Nolan and Kevin Whelan, Geography Publications, Dublin (*Go raibh maith agat*)
Tony O'Malley illustrations and quotations © Jane O'Malley
W. S. Graham poem © W. S. Graham Estate
Bernard Leach letter © Bernard Leach Estate (thanks to John Leach)
Patrick Heron quotes © Patrick Heron Estate

Photographs Copyright David Whittaker except the following:
AL – © Andrew Lanyon FEM - © F. E. McWilliam JOM – © Jane O'Malley
MW – © Monica Wynter RS – © Roger Slack

Acknowledgements:
Thanks especially to Jane O'Malley for allowing me to spend an unforgettable day with her and Tony two months before his death. Her wholehearted commitment to Tony in life as well as death is a very touching labour of love. During research for this study her generosity has been unstinting and she couldn't have been more helpful; her hospitality is second to none, always ensuring my glass was never less than half full.

The simple dedication fails to convey the unique privilege of having known both Janet and Roger Slack. It has been a real pleasure going through Roger's outstanding archive and partaking of his fount of knowledge and insight.

In addition my sincere gratitude goes to the following, in alphabetical order:
the late Wilhelmina Barns-Graham broke the news to me of Tony's death which led to her sharing quality time with me; Bob Devereux for oratorial exhortations and the use of an interview with Tony; Lorna Donlon for archival assistance; John Emanuel for the self-taught view; all O'Malleyites owe a great debt to Brian Fallon, who tirelessly pioneered the early spade work; Katherine Heron for the eagle's view; Andrew Lanyon for being positive about negatives; Jeremy Le Grice just for being; Brian Lynch, a class act to follow; Jim Mitchell, a man from the san.; Patrick J. Murphy for infectious enthusiasm and a magical mystery tour in Dublin; Breon O'Casey for some gentle words; Ignatius O'Neill came to the rescue on the 11th hour – literally; Roy Ray for the aerial view; Michael and Margaret Snow, for heartening reassurance on an early draft; Sarah and Bryan Stoten (of the Stour Gallery, Warwickshire), for initial facilitations, encouragement and putting Tony in the frame; The Taylor Galleries, Dublin (Patrick and John) for a friendly staging depot; Nancy Wynne-Jones and Conor Fallon for Trevaylor musings; Monica Wynter for the Celtic view and exposing Tony's vestments.

It is difficult to reproduce the textural fidelity of an O'Malley work on the pages of a small book such as this, and I urge the interested reader to look to Brian Lynch's large book, with over 300 illustrations, recently reprinted and to seek out the works in the flesh wherever they can.

Special thanks to Penny and Alice for keeping the home fires burning; their irrepressible good humour turned many a potential disaster into a good laugh. Thanks for proofing and technical know-how.

Keith Rigley navigated the rough typesetting waters with aplomb – cheers as usual chap.

Printed by Information Press, Eynsham, Oxon, UK

CONTENTS

Scenario 6

Early Years 8

Cornwall 13

Later Years and Conclusion 62

Appendices:

 1 Inscape – Life and Landscape in Callan and
 County Kilkenny 68

 2 Selected Comments about O'Malley 88

Select Chronology 92

Further Reading 95

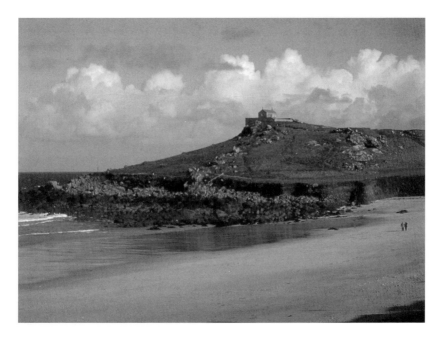

The Island, St Ives

SCENARIO

In the 5th century, according to legend, a group of missionaries were setting sail from Ireland's shores heading for Cornwall. A princess Hya or Ia had hoped to accompany them, but for some unknown reason she missed the boat. In despair she knelt down on the beach and prayed. Noticing a small leaf floating past she touched it with her rod and it suddenly expanded before her eyes. Trusting to the Almighty she embarked across the sea on the leaf and in time reached a sheltered cove about 20 miles from Land's End. Here she brought Christianity to the area and a little chapel was built to her on the promontory known as The Island (February 3rd is her feast day). The cove became known as St Ives.

Almost 1500 years later a former bank clerk (whose destination was also St Ives) set sail from Ireland's shores. His mode of transport was marginally less wondrous than St Ia but none the less seaworthy: he took the cattle boat from Rosslare (his route less direct; the boat having docked at Fishguard in Wales, a complicated and lengthy rail journey ensued). On arrival at the small fishing port he soon found lodgings which just happened to be by The Island.

Perhaps the comparison between an ancient Irish saint and Tony O'Malley ends there; but he was also blessed with transformational powers, this time using a paint brush. His beatification remains on hold.

O'Malley, Porthmeor Beach, 1975 [RS}

Winter Sea, Mount's Bay 1967 9 x 7¾in. gouache and ink

EARLY YEARS

To describe the Ireland of the '50s: there was an overlay of the most unutterable feeling of stagnation, and the feeling of an establishment that was incapable of thought or feeling or any kind of inspiration. It felt as if Ireland was ruled by knaves, by knavish fellows of all kinds. But in our own lives it was not a life of quiet desperation but of unquiet desperation. There was really nothing but dances. I wasn't a very great man for going to dances, but you went to dances out of some kind of awful frustration and you usually ended up getting too drunk and losing touch with the main point of view if you like, half way through the night. You went home drunk and wet. You were all the time trying to achieve what was unspeakable in the '50s; the unspoken of, that was burning under every hedge.

The establishment was utterly and completely philistine, the arts meant nothing. You couldn't call yourself an artist, you couldn't call yourself a painter; you were just a fellow who did something on a wet Sunday or you went out on an evening and did a drawing or a painting, but you didn't call it art because art was something that was achieved by someone maybe from middle-Europe. Nobody from the countryside was capable of achieving anything like that because we were subject at that time to what was called the 'diploma 50s'; anybody who did anything had to have a diploma to show their credentials. But being out of touch with other artists made you feel you were just doing it for yourself. Nobody pretended to understand it, although it wasn't very difficult to understand but it didn't mean anything. You'd be better off being a hurler, that would have been a more important thing, or a footballer because sport then was far ahead of the arts and still is. So we suffered, not in silence, we had many a good laugh, many jokes out of the whole thing, out of the frustrations and out of political characters who thought of themselves as very important. We made fun out of that, it didn't mean that we were morose and sometimes fairly sullen; we suffered many hangovers, but we thought all these things were being offered up for something, maybe for redemption of something we wouldn't see in our lifetime. O'M

From the RTE TV documentary *Places Apart*

O'Malley was born on 25th September 1913 in Callan, County Kilkenny; the eldest of four children (with a brother Matty and two sisters Rita and Sarah). His father, Patrick, was a salesman for Singer sewing machines while his mother, Margaret (née Ryan), owned a small shop in the town and for a time ran a lending library. (A favourite read for the household was Bram Stoker's *Dracula*, while Tony retained a lifelong appetite for reading.) The O'Malleys were of a colourful ancestry from Clare Island off the west coast of Mayo (their motto being *Terra marique potens*, meaning 'powerful by land and sea'). The 16th century 'Pirate Queen' Grace or Granuaile O'Malley is the most infamous of the forebears.

After the convent, the local Christian Brothers' school was his sole formal education. In 1933 he joined the Munster and Leinster Bank and for the next 25 years, apart from a year in the army (1940-'41) during what was known locally by the understated euphemism 'The Emergency', he had a nomadic existence, working at various bank branches including Ennis, Dublin, Monaghan, Limerick, Wexford, Enniscorthy and New Ross.

On the face of it these years sound routine and uneventful. However starting with his brief army service O'Malley's life was dominated by ill health. TB made him a regular patient at the sanatorium, resulting in several operations which included the collapsing of a lung as part of the treatment, punctuated by periods of convalescence. During this time he drew and painted steadily, gradually honing his skill and technique (his many years in the presence of illness and death provided a key stimulus for his art throughout his life). Through his love of nature he had been drawing since he was a boy, but it was not until 1945 that he painted his first work in oils. Cezanne and Van Gogh were obvious influences, but the fact is O'Malley had very little exposure to art by way of exhibitions or even books. The art works with which he was best acquainted were the carvings and sculptures from local churches and ruins particularly the 12th century Cistercian Jerpoint Abbey and the striking work done there in the 16th century by Rory O'Tunney. It is difficult now to imagine the philistine context under which O'Malley laboured in Ireland during these years. It was not the done thing for a young man to get involved with the arts; such behaviour was treated with scornful ridicule and hostility and he would be accused of 'getting high notions like the crows'. Therefore O'Malley struggled under the double weight of illness and a cloak of secrecy. His story is all the more remarkable as a long term invalid who refused to be

worn down by pain and indifference in an alien environment by drawing from hidden well-springs of determination and creativity.

It was in the early part of 1955 that O'Malley chanced across an advert in *The New Statesman* for a painting holiday, during the summer, in St Ives, Cornwall. This was a remarkable stroke of luck and for him personally, and for the history of Irish art, it was a crucial turning point.

At this time, 10 years after the war, St Ives was shaping up as a leading centre of European art. Ben Nicholson and Barbara Hepworth had settled here in 1939 (soon to be joined by the Russian constructivist Naum Gabo); it had been home for many years to the 'primitive' painter Alfred Wallis (who died in 1942) and Bernard Leach had set up his famous pottery in the 1920s.

The area had been a magnet for artists since the 19th century and at least two other Irishmen, Stanhope Forbes and Norman Garstin, were leading members of the nearby Newlyn School.

The artists working in the area in the 1950s who went on to long lasting international acclaim included Peter Lanyon, Bryan Wynter, Patrick Heron, Terry Frost, John Wells, Wilhelmina Barns-Graham, Sven Berlin, Nancy Wynne-Jones, Roger Hilton, Denis Mitchell, Breon O'Casey, Karl Weschke and Paul Feiler, with the master wordsmith Sydney Graham keeping them on their toes (Nicholson was to leave for Switzerland in 1958).

It cannot be overstated what a contrast this must have been for O'Malley; here was a milieu in which it was almost odd not to be an artist. Having said that, it was notable in these times that the artists integrated very amicably with the local fishermen and farmers. With his small town background and ability to mix well, this was an added bonus for O'Malley.

On this first trip O'Malley stayed in a guest house in Island Road run by Bill and Mary 'Boots' Redgrave (where he cut a most un-bohemian figure as the bank clerk on holiday in tweed jacket, jumper, tie and tweed cap). Bill Redgrave was also one of the main tutors, along with Peter Lanyon, at the art classes at St Peter's Loft, an old fisherman's warehouse. On this occasion there were six 'students' in all, with a teenage Jeremy Le Grice and four women joining O'Malley. It is a curious fact that Redgrave was a conservative painter who disapproved of the abstract style; perhaps he acted as a counterbalance to Lanyon's adventurous approach. O'Malley liked Lanyon, he found him generous with an enthusiastic and energetic presence; he also felt him to be a true innovator who had broken through the appearance barrier. It's worth

noting that O'Malley was by now an accomplished middle-aged artist and five years older than Lanyon, but there was still much to learn from his younger fellow Celt. Up to this point O'Malley's work had been mainly figurative, akin to German Expressionism, and was perceived in St Ives to be rather old fashioned, but he now started to expand his technique. He always felt unhappy about the term 'abstract art' and preferred to call it 'non-objective'. His copy of Patrick Heron's *The Changing Forms of Art* is dated 1955 and contains marks of emphasis in the essay *The Necessity of Distortion in Painting* as well as portrait sketches throughout. One of the paintings to survive from this trip was *St Ives – the Old Gasworks*, now the site of the Tate Gallery.

Back from the holiday he felt even more frustrated with his day job. In the autumn of 1957 he returned for another painting trip (this time flying to London with a bad dose of flu). These trips were to be the nearest he ever got to attending art classes (by all accounts they were fun events offering encouragement and advice rather than anything formal).

Sketch by O'Malley in Heron's *The Changing Forms of Art*

In 1958, with recurring hearing problems (a form of tinnitus, a side effect of massive doses of streptomycin for his TB), he gave up the bank on the grounds of ill health. Soon after this his dear brother Matty died of a heart

attack which left him bereft and incapable of practicing his art. Having tasted the freedom of a dedicated art colony he had clearly reached a point of despair. But he still felt torn about making a decision to leave Ireland and throughout 1959 he wavered until finally, with much encouragement from the poet Padraic Fallon (who was something of a father figure to him), the cattle boat proved irresistible and in May 1960 he turned his back on his homeland and set sail on a highly personal and lonely odyssey. Local people thought he was insane to leave the security of a decent job to go and do something as 'frivolous' as art. He had left an Ireland which had not changed much since the 1930s when another illustrious, though very different, exile had departed its shores saying that 'it couldn't give a fart in its green corduroy trousers for culture'. That exile was Samuel Beckett.

In Ireland I was attached to all the old historic places which were loaded with history and had a potency for me. They weren't just landscapes, they were powerscapes if you like; they were invested with a certain type of power for me. I continued painting them even after coming here; it was an invisible force, but I had to recognise it as a certain kind of force inside myself. O'M

Boots Redgrave [RS]

12

CORNWALL

1960s

Cornish time is very like Irish time: the people are always wanting to be up and away, but never do! O'M

O'Malley returned to the Redgraves where Boots seemed happy to support and look after him. He had a small pension from the bank to help him along and he rented the Old Piazza Studio. Though working in a very different cultural environment from his Kilkenny home (or the ancestral home of Clare Island) he still drew heavily from his memories and experiences. Family and places recur in a dreamlike and expressionist style with the titles: *Walking Home, Clare Island; Portrait of the Artist's Parents; Landscape with Figure, Clare Island; Wicklow Coast with Wreck; Near Callan; New Ross; Dunes, Arklow; Knockmore in Winter, Clare Island; Winter Landscape, Ireland; Old Irish Cross, Ahenny; Currach, Clare Island; Matty's Red Kite; Crom Dubh* (a Celtic harvest deity). Such a proliferation of Irish references suggests a strong feeling of homesickness and he was clearly haunted by the ghosts of the past for them to remain the foremost subjects of his art. He could now explore his roots in depth from a distance.

A sketch exists of the poet W.S. Graham (Sydney), dated 1960 (charcoal and gouache). Graham was a colourful Scot living in a coastguard cottage, with his wife Nessie, out at Gurnard's Head. They were to hit it off and a few years later Graham dedicated a poem to O'Malley *Master Cat and Master Me* as a thanks to the painter for looking after his cat. They also combined their arts on the painting *Owls Ruling a Wood at Night*.

O'Malley's new found life as a member of the St Ives art community almost ended before it had begun. Later in 1960, while visiting a friend at The Old Bakehouse, he suffered a heart scare which turned out to be bad angina. It was serious enough for him to receive the Last Rites from Father Delaney, not for the last time; Dr Roger Slack came to the rescue, not for the last time either, and he was taken into hospital briefly but soon recovered.

But it was in May 1961 that he suffered a serious heart attack while at the Redgraves. Dr Slack was called on to administer to the ailing artist and he was rushed to the local Edward Hain Hospital. By an extraordinary coincidence, the painter Bryan Wynter also suffered a heart attack in the same

week and the two men were to share a twin room. This proved a highly attractive and entertaining double act for the nurses (Wynter was a great punster and practical joker). They had met before, but this exceptional experience made them close friends. Wynter marvelled at O'Malley's endless stock of stories, and later commented that the Irishman never repeated himself. Just as well, as O'Malley used to wake very early and want to chat. As with his days at the sanatorium, he used the opportunity to make many drawings of his fellow inmates. Having been allowed home he had a relapse within a week. O'Malley then had a spell at Tehidy Hospital near Camborne before being generously taken into the household of Patrick and Delia Heron, demonstrating the affection in which he was already held. Their house, Eagles Nest, was in a magnificent location on high ground overlooking the moors and the Atlantic near the village of Zennor (and within sight of the remote Carn Cottage of Bryan and Monica Wynter).

1962 saw his second solo exhibition at the Sail Loft Gallery. He didn't expect to do much business but in fact he sold nine paintings at about £30 each.

Around this time Francis Bacon spent a few months in St Ives and O'Malley got to know him slightly (Bacon was born in Dublin in 1909). When Bacon returned to London O'Malley commandeered a painting on board that he left behind and used the reverse for his own work.

O'Malley at his Sail Loft Gallery show in 1962, with Elena Gaputyte (centre), the Lithuanian sculptor and gallery owner

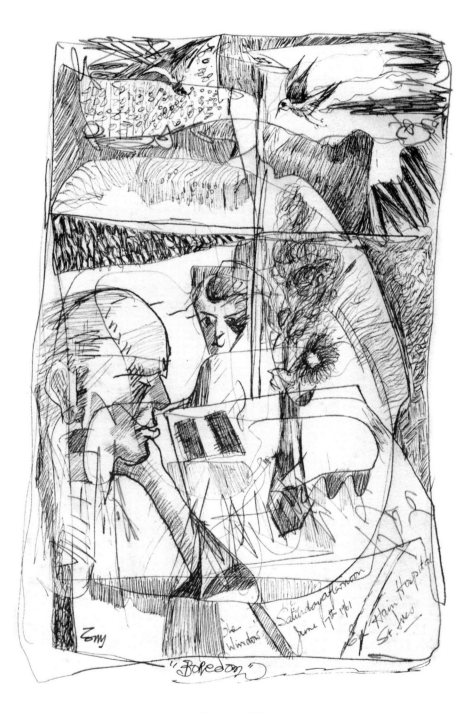

Boredom from sketchbooks 1961

Though my painting changed, apparently, from direct figuration it remained close to nature. Nature was there for me before art. O'M

The Welsh painter Nancy Wynne-Jones (who had studied closely under Lanyon) was living in the Battery, a small fort on The Island, and had become friends with O'Malley. In 1962 she bought a spacious country house, Trevaylor, near the village of Gulval, on the outskirts of Penzance. It was mainly 18th century, though parts of it dated from Elizabethan times, and was surrounded by ten acres of garden and woodland. Several outbuildings were converted into studios. Boots Redgrave rented part of it with the intention of running an art school and brought along her lodgers, O'Malley and the Canadian sculptor Bill Featherstone. The Grahams would soon move from Gurnard's Head to join them in the lodge across the road from the main house (it was named 'Little House' until Graham changed it, somewhat prosaically for him, to 'Woodfield'). Wynter also rented a studio here for a time and most of the artists in the area would visit to compare notes and exchange ideas. Trevaylor, in its relative isolation, would now become an important sub-colony of the main St Ives group; O'Malley has compared it to a kind of self-sufficient university. It wasn't all work of course: at one party Featherstone fell out of an upstairs window onto a bed of red-hot pokers, with the 'on-call' Dr Slack having to sew him up in the middle of the night, and he was often to be found wandering about the nearby woods with his violin playing *Tea for Two.* On the more artistic front Featherstone carved a large totem pole from a telegraph pole which stood outside the Gurnard's Head Hotel for years.

From the window of his room O'Malley looked across to the sea and St Michael's Mount, but behind the house the country is ancient, mysterious and pagan. West Penwith is a peninsula, seven-eights of which is surrounded by the ocean. Despite the appearance of remote wilderness, this is a land etched with human activity going back to Neolithic and Bronze age times with stone circles, standing stones and quoits, Iron age field patterns and the remains of tin and copper mining from antiquity up to the Industrial Revolution. This chimed with O'Malley's acute sense of the history of place, particularly this Celtic place. It had a good deal in common with the Ireland he knew and the ordinary Cornish people had toiled and suffered to eke out an existence for centuries, often under exploitative regimes, which paralleled the experiences of

Still Life. 1961 23¼ x 36 in. oil on board

Irish people in the 18th and 19th centuries. For the next four years at Trevaylor O'Malley mined this rich terrain to create some of his finest art.

There are few canvases from this time. Partly because of the costs, he worked mainly on board, usually four feet by two, and any other material he could find, including old newspapers. He liked working on board as it allowed him the extra tactile dimension of scoring and marking reminiscent of his Kilkenny forebears (the linear marks also resembled the Ogham alphabet, the earliest form of writing in Irish from the 4th century).

Driftwood and other found items were incorporated into collages and constructions. Wynne-Jones gives an account of a visit to Botallack mine where O'Malley was delighted to find chimneys full of old soot which he collected and mixed with linseed to make a unique black paint. It was important for his craft that materials to hand, with their own history, became incorporated.

He drew constantly. He had always kept a visual diary, so he never abandoned the figurative, though the paintings now appeared more abstract. This was not a theoretical abstraction but grew organically from an emotional base. His palette remained dark and dour with subtle gradations of browns, greens, grey with black and white; but they are anything but dull with rich accretions of paint suggesting a fertile, animistic and elemental subterranean life much like the environment in which they were spawned. There is a strong feeling of solitude in a harsh landscape in a bleak season with the titles: *Winter Silence; Winter Owl; Winter Landscape; He Searches Winter, the Windhover; Reflections of an Old Landscape; Hawk's Landscape* and the starkly evocative *Self-Portrait, Winter, Heavy Snowfall at Trevaylor* (one of a large corpus of often intriguing and revealing self-portraits). In proper harmony with this sense, during the first winter here, a recording of Schubert's *Winterreise* sung by Fischer-Dieskau could be heard day after day coming from O'Malley's studio.

Owls recur in many of the drawings and paintings. The woods around Trevaylor were busy with their nocturnal activities and O'Malley kept a nightly vigil attempting to get on intimate terms with them by imitating their hootings. No matter how late he retired he was always a good early morning worker and had often completed a considerable amount of work before discussing comparative religion with Wynne-Jones over breakfast.

Despite his cherished gregariousness, this period has been interpreted as showing a dark, melancholic side to O'Malley. Illness and death had shadowed

Zennor from sketchbooks 1961

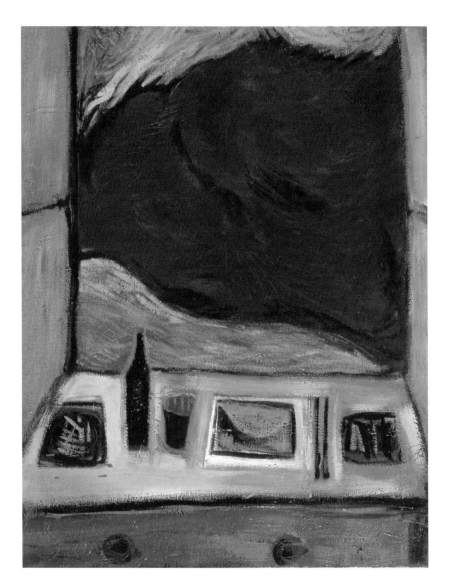

Breezy Summer Evening from my Window (Trevaylor).
1965 36 x 28 in. oil on canvas

Winter Myth. 1962 16¾ x 24½ in. mixed media

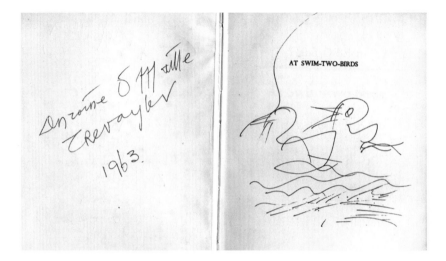

From O'Malley's copy of Flann O'Brien's novel

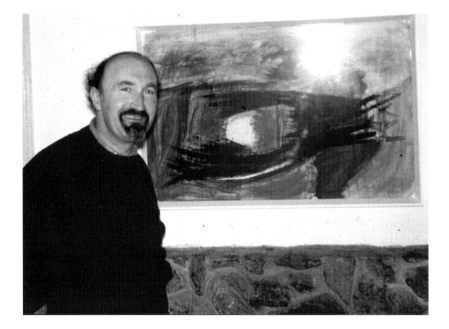

O'Malley with painting *Wicklow Coast with Wreck* 1962 [RS]

him for many years and in conversations he made it clear he felt he was working on borrowed time. This heightened his awareness and acted as a focus for work that is existential in its intense contemplation of transience and the fact that our mortality is, at the end of the day, a private and lonely experience. By contrast there were the exquisitely delicate studies *Morning Bird and Summer Morning, Trevaylor* and the pastel and pencil *Doves, Trevaylor* that have a Klee-like ludic quality.

He now had a Lambretta motor bike for exploring the Cornish lanes and getting to the pub. The Gurnard's Head Hotel or The Tinner's Arms in Zennor where particularly popular meeting places (in St Ives it was The Sloop and The Castle Inn). The return journey could prove hazardous, for various reasons. On one occasion, rounding a bend, O'Malley was confronted by a truck carrying an extra wide load of planks of wood; he ducked under the planks just in time, narrowly avoiding decapitation to fight another day.

The Stockport painter Alan Lowndes, who lived with his family in nearby Halsetown, became a good friend. Lowndes was also self-taught from a northern working class background. He has been described as truculent, liking nothing better than a good argument. He shared a widely read and well stocked brain with O'Malley.

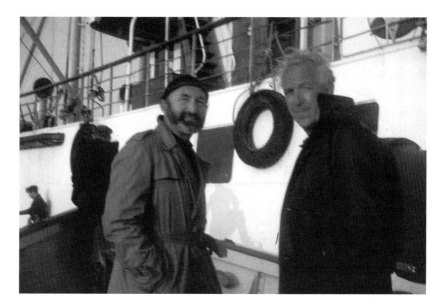

O'Malley with Dr Slack on the Scillonian, 1964 [RS]

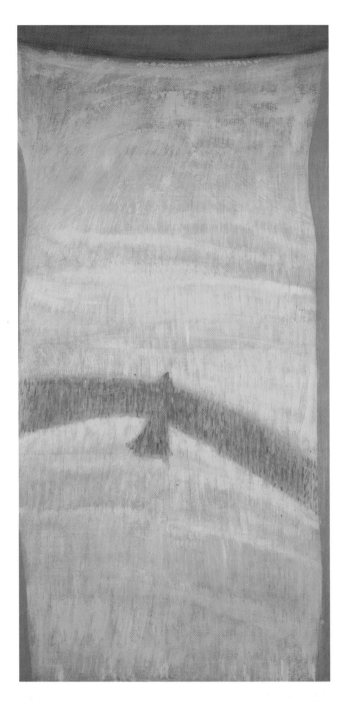

The Hawk's Shadow Sweeps the Cornfield. 1966 48 x 24in. oil on board

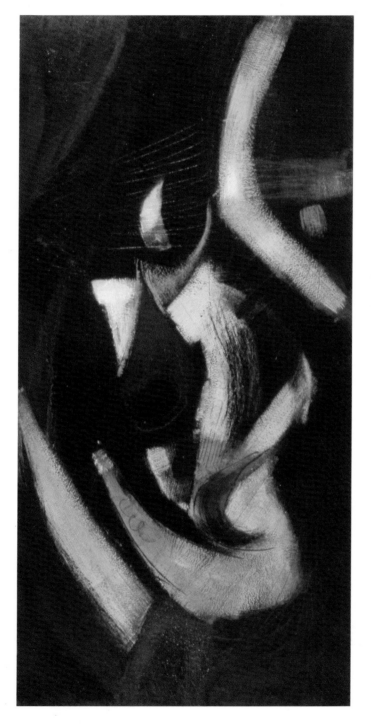

The Watching Windhover. 1965 24 x 48 in. oil on board

In the spring of 1964 he spent time on the Isles of Scilly with Dr Slack and his wife Janet. He always felt at home in this even more remote place. There was a certain parallel between Callan and St Ives as small towns, with a sense of interiority, and St Martin's and Clare Island with a sense of the open surrounding ocean. Having taken the Scillonian from Penzance to St Mary's they would travel on a steam driven harbour launch, the Andy Capp, to St Martin's, choking on the smuts along the way.

It was on August 27 1964 that Peter Lanyon crashed his glider at a small aerodrome in Somerset. He survived with a cracked vertebra and in hospital in Taunton he chatted with visitors and was anxious to get back into the swing of things. On the 31st he died suddenly from a blood clot; he was 46 and left a widow with six children. The whole community, not just the artistic, was numbed by the abrupt cessation of such a dynamic presence. He had become a legend in his own lifetime and was even well known and respected in

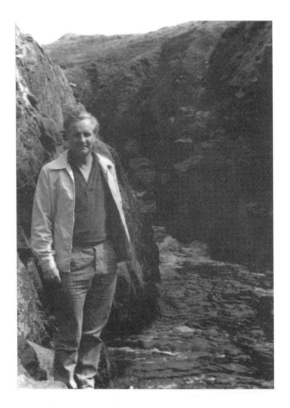

Peter Lanyon at Pendeen ca. 1963 [AL]

America. He had revolutionised the art of landscape painting, arguably, more than anyone since Turner and there can be no doubt that he seriously informed O'Malley's work from their first encounter nine years previously. Though they remained very different painters, particularly in scale; O'Malley was always a tighter painter. Lanyon was less an influence on his painting than an exemplar with his courage to pursue his own vision and break free of imposed styles and modes of representation.

Sydney Graham responded to the loss with his great elegy *The Thermal Stair*, while O'Malley also showed his depth of feeling with two paintings *Hawk and Quarry in Winter* and *In Memory of Peter Lanyon* both oil on board. The quarry and hawk were near Newmill along from Trevaylor and clearly take on a symbolic aspect while the latter gives a dark vertiginous sense of falling into a thermal vortex.

O'Malley was to take Lanyon's example further by going up in a glider as a passenger. He recounted how a falcon flew alongside the plane before giving O'Malley and his pilot a demonstration of how to *really* fly. On landing he attempted to catch this experience, in works which included *He Searches Winter, the Windhover*, a dark, energetic work of darting angularity, part of a series of windhover related paintings. 'Windhover' is a common south and west country word for a kestrel or falcon which O'Malley probably first encountered in Gerard Manley Hopkins poem *The Windhover*, to which he was introduced by Padraic Fallon. (This important poem was to play a part not only in his life but also his death, when Seamus Heaney read it, many years later, at his funeral.) In a similar dark work from this time, *The Grave of the Windhovers*, he incorporated an old vest stretched across the painted surface. *The Falcon's Gyre* was another scored painting vigorously exploring the spatial dimension of flight, as was *Vortex of Winter Birds*.

O'Malley's art could be described as an ornithologist's delight. A casual glance through a catalogue of his titles reveal the names of many types of bird, including the falcon, hawk, owl, dove, pigeon, bittern, starling, jackdaw, blackbird, crow, rook, heron, sparrowhawk, egret, parrot, pheasant and thrush; while the generic word 'bird' exists in a multitude of titles. This was a species clearly emblematic of the freedom of gravity for O'Malley, and his work is littered with beaks, feathers and bird-prints (birds play a major part in Celtic art and myth). As a highly musical man (he played the accordian and harmonica and enjoyed listening to Bruckner and Mahler), it should come as

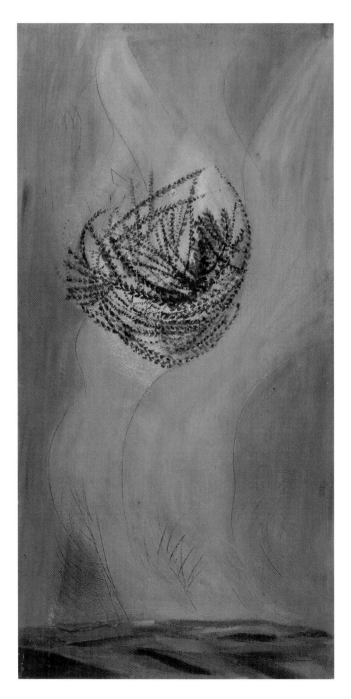

Vortex of Winter Birds. 1965 48 x 24 in. oil on board

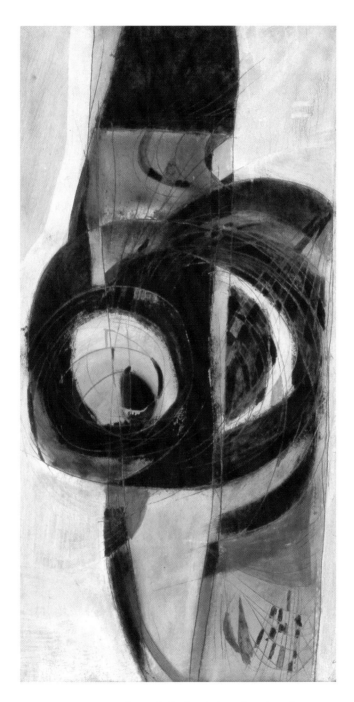

The Falcon's Gyre. 1965 48 x 24 in. oil on board

no surprise to find bird song infiltrating the paintings. In 1966 he painted *Bird Song Circle – Blue* and *Bird Song Circle – Red,* inspired by a recording of Messiaen's *Le Reveil des Oiseaux.* Oil on board, they present a kind of startling, concentric and chromatic musical score. There's no doubt O'Malley had some synaesthetic sense in that sounds appeared to him as colours (he also spoke of painting 'the music of the poplar trees': being the rustle of the leaves in the wind). He even found that least musical of birds the crow, with his lonely caw, a comfortable stimulus. His fascination for birds brings to mind a phrase from the French poet Paul Valery: 'One should be light like a bird, and not like a feather'; this was in reference to writing poetry but it could just as well be applied to O'Malley's whole *ouevre.*

Self-awareness is very important in painting, but not your ego. O'M

O'Malley painted everyday, but for some years now the painting he did on Good Friday began to take on a special significance. Though he was no longer a practising Catholic, the drama of Christ's Passion would continue, for the rest of his life, to hold a potency for him as an artist. This ritual reveals O'Malley to be, deep down, a painter on a spiritual quest, where the act of making art was an attempt at some kind of redemptive journey. The *Good Friday* of 1966 is a quietly powerful work, its pointed cruciform shape expressing a concealed, radiant vitality. He drew from many religious sources: the Ireland of his youth still maintained pagan ways in harmony with the Christian in the form of folklore, superstition and visitations from the otherworld which included banshees and fairies (Cornwall too has a long, rich tradition of legend concerning witchcraft and hauntings, with piskies almost the equivalent of leprechauns). Apart from the psychological enter-tainment value, much of this tradition was also rooted in pagan festivals which celebrated the natural world and traced the rhythmic cycles and trans-formations of the seasons. This was of crucial importance to O'Malley and the seasons, as well as the birds, appear in a copious number of his titles.

He also looked to the East and Bernard Leach became his mentor and guide through the complex field of Oriental aesthetics and philosophy (though he was already well versed in comparative religion). Leach had spent some years working in China and Japan and had imported these ideas into the work ethic at his pottery in St Ives. Though certain artists were scornful that mere crafts were not to be treated on the same level as their fine arts, O'Malley

found the principles of applied art highly relevant. Particularly the book *The Unknown Craftsman* by Soetsu Yanagi (which was adapted and partly translated by Leach) and an article *The World of Shibui* from a 1961 *Japan Quarterly*. These works deal with how simple people make objects of a certain crude beauty with a rough irregular pattern; individualism is not imposed on the work as it emerges, almost of its own accord, from the interactive process of artisan and materials. 'Objects born, not made' is Yanagi's maxim. *Shibui* is a Japanese concept which eludes easy definition and translation into a western language and culture. It refers to a bitter, astringent taste (originally used in the Tea Ceremony) and in art signifies a subdued balance of dark colours, not showy but rich in quality. Furthermore, Yanagi had this to say: 'It is not a beauty displayed before the viewer by a creator; creation means here, rather, making a piece that will lead the viewer to draw beauty out of it for himself. In this sense, *shibui* beauty, is beauty that makes an artist of the viewer'.

Shibui, in turn, developed from *wabi-sabi* or the Japanese appreciation of things impermanent, imperfect and incomplete. Beauty for beauty's sake is eschewed and the natural process of degradation and decay are seen to give an object a richer organic life. All of these notions take their impetus from Zen Buddhism, and the essence of Zen has to do with a spontaneity going beyond personality to achieve a realisation where the duality of the observer and the observed, the knower and the known, melts into a unified experience. O'Malley's art reveals him to be pantheistic in his reverence for nature, and the whole environment, including rocks and stones, was seen as an animated, pulsating pattern of forces.

His library included *Zen and Japanese Culture* and *Sengai: the Zen master* both by Suzuki as well as the comprehensive *Sourcebook in Chinese Philosophy* (bought for him by Dr Slack), *The Tibetan Book of the Dead* and a well-thumbed selection of writings by that most Buddhistic of Christian mystics, Meister Eckhart. O'Malley's was a complex weave of early Christianity, paganism, Taoism and Buddhism that resulted in a form of Celtic-Zen, though he maintained rather a love–hate relationship with the local priest Father Delaney, and felt the Catholic church was still out to get him. On one occasion, while visiting Leach in hospital the priest said to him: 'The trouble with you Tony is that you haven't suffered enough' to which our stoic artist replied: 'I'm not a professional sufferer'.

Unfortunately the Trevaylor idyll was drawing to a contentious conclusion.

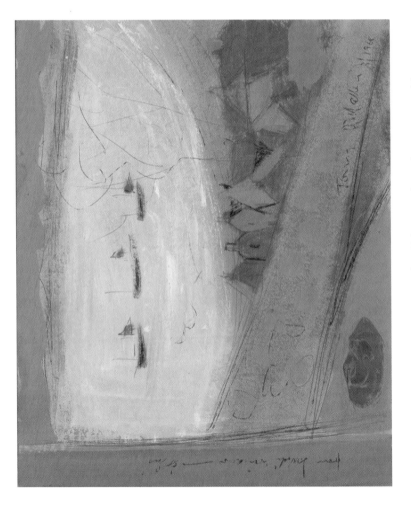

From Isabelle's Window – St Ives Bay. 1968 9 x 11 in. gouache and pen on toned brown paper

As more and more hangers-on were taking advantage of the facilities and starting to crowd the place out, it became increasingly difficult to find the privacy to do serious work. Wynne-Jones married Conor Fallon (who was then a painter but has subsequently become one of Ireland's finest sculptors, working in steel and bronze), son of the poet Padraic, and she now had a serious falling out with Boots. The Grahams were about to move to a cottage in Madron where they lived rent free, courtesy of Wynne-Jones generosity, for the rest of their days. Sides were taken over the dispute and, in 1966, O'Malley moved to Penzance where he rented a bow-windowed studio flat in a mews behind The Abbey Hotel.

More than forty years on, much of the work achieved by O'Malley at Trevaylor still speaks to us with a fresh, timeless quality. It was where he came of age and all the simmering potential that had been like a caged bird in Ireland was at last liberated, and allowed to take wing.

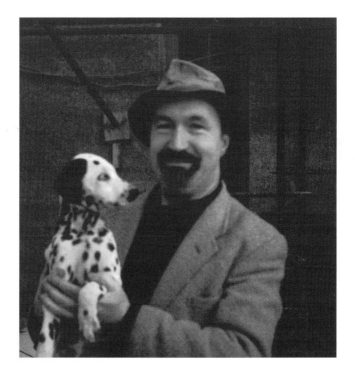

At Trevaylor with Boots' dog Badger (additional black spots courtesy Bryan Wynter's paint brush). O'Malley had a lifelong fondness for battered old hats, even inheriting some of Wynter's cast-offs [RS]

Abstraction does enable you to get under the surface, to get beyond appear-ances, and to express the mind. But abstraction for its own sake does not interest me. O'M

In the summer of 1966 O'Malley was working hard on a series of cornfield paintings: *Cornfield in a Strong Breeze; Cornfield on a Stormy Day; Morning Wind on the Cornfield; Ripe Cornfield in the Wind* and *The Hawk's Shadow Sweeps the Cornfield,* the latter suggested by his gliding experience. They are bright and breezy with a strong sense of movement. Like the windhover series, he worked on various related pictures at the same time. These were followed by a darker series: *Winter Silence; Winter Silence II; Winter Morning, Penzance, The Abbey* and *Penzance, The Abbey* made up of horizontal and vertical lines in a dull grey wash with a central division making them look like open books. They are among the bleakest of his works. *Starlings and Winter Landscape at Ding Dong* applies a similar technique in greens, but on the horizontal and resembles a fruit sliced open with coloured veins. (Ding Dong is said to be the very oldest of Cornish mines and local lore even associates it with a visit from Joseph of Arimathea and a youthful Jesus Christ.)

In 1967 O'Malley returned to Ireland for the first time since his self-imposed exile. He travelled with Bryan Wynter's family and they rented a cottage in Dingle Bay. After about a week O'Malley left them, travelling back to Callan to visit his sisters and some old acquaintances.

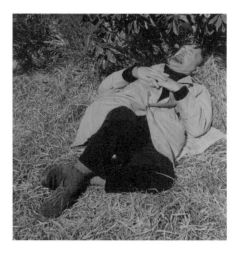

Post lunch nap, Ireland 1967 [MW]

Leda and the Swan, from sketchbooks ca. 1961

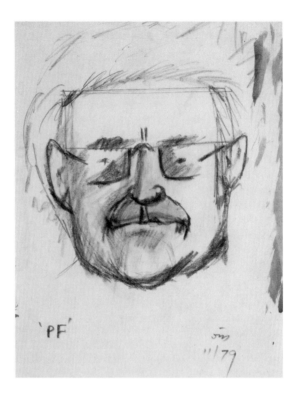

Padraic Fallon 1979 10 x 7 in. conté

The same year he moved back to St Ives and lived and worked in the Ship
Studio in St Peter's Street.

The other day a line of Keats came into my head and begot a painting. O'M

In the same year, two of O'Malley's dearest friends, Padraic Fallon and his wife
Don, moved from Ireland into the Graham's old cottage opposite Trevaylor.
Fallon's mindset was close to O'Malley; he was a countryman and a
considerable poet who drew from Irish, classical and oriental mythology.
He was the subject of many portraits by O'Malley. Even long after he died
in 1974 the artist continued to paint and draw him from memory. People
who knew O'Malley well all mention, with awe, his astonishing memory.
Images of events, places and people didn't seem to fade for him. His reading
was omnivorous and nothing was forgotten. As well as history, he was always
interested in the struggles and foibles of humanity and was widely read in

literature, including Joyce and Proust. But it was in poetry he found a kinship with his own art; Hopkins, Yeats, Keats, de la Mare, MacNeice and Eliot were among his favourites. Poetry was invariably in his mind and nourished his work in subtle ways. He got on particularly well with artists who were equally well read in poetry, including Wynter and John Wells, and he was far more likely to want to talk about literature and history than to talk about art. A striking painting from 1968 is *Celtic God of Music, Aengus*, a glowing picture with a strange cyclopean head scored with harp strings, echoing Yeats' poems *The Song of Wandering Aengus* and *The Harp of Aengus.*

'Inscape' became a key term and idea for O'Malley and would feature in the titles of many paintings of the 1980s. This is from Hopkins (who had been a Professor of Classics at University College Dublin; unfortunately the Liffey water failed to agree with him and he died there of typhoid in 1889 and the world had to wait another forty-one years for his collected poetry to be published). He coined 'inscape' to describe the integrated patterns and forms seen in clouds, flowers, trees, wood, hills, waves, streams, glaciers, sunsets, constellations and so on. The feeling of this perception of inscape on an observer he called 'instress'. Neither term was ever clearly defined by Hopkins, but their application can best be seen in his journals and notebooks which contain some of the finest descriptive prose in the English language, where the words he uses take on the form of the thing or process described. For Hopkins this was a means to intense contemplation of the natural world. O'Malley used 'inscape' in a more idiosyncratic way, contrasting it with 'outscape': the mere appearance of a thing; it was his way to go beyond this appearance to discover the hidden inscape, and he believed the deeper he went into a thing the deeper he went into himself. This is the essence of Zen.

In 1969 the Arts Council were bequeathed two cottages for the use of low-income artists in St Ives; O'Malley was means-tested and was certainly found to qualify. He moved into Seal Cottage in Back Road West, immediately next door to Alfred Wallis's old cottage and he would remain happily here for the rest of his Cornish sojourn. He later acquired a studio, thanks to Breon O'Casey, overlooking Porthmeor Beach near to Patrick Heron's studio and just a few doors along from Wilhelmina Barns-Graham and Bernard Leach.

As the 1960s drew to a close and he approached his first decade away from Ireland, he could look back and feel pride in an impressive, solid body of varied work. He was much respected by his peers, but they puzzled slightly over his

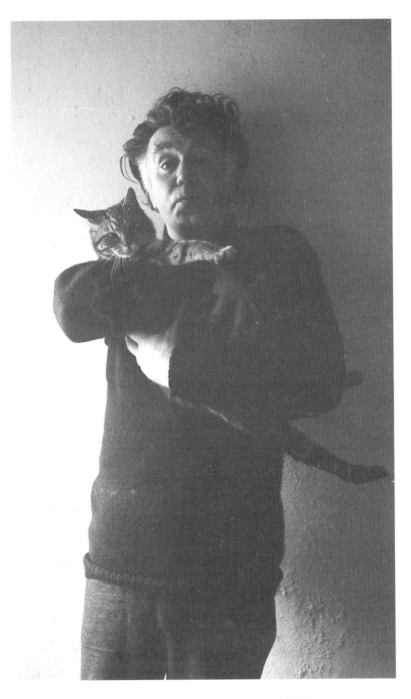

Sydney Graham with cat, April 1968 [AL]

MASTER CAT AND MASTER ME

(For Anzoine O'Maille)

The way I see it is that Master
Me is falling out with Servant
Me and understairs is live
With small complaints and clattering.

The dust is being too quickly
Feathered off my dear objects.
On the other hand I find myself
Impeded where I want to go.

Even the cat (He has no name.)
Is felinely aware that Master
House's bosom is not what
It used to be. The kitchen door

Swings on its hinges singing on
A foreign pitch. The mice have new
Accents and their little scurries
Have acquired a different grace.

At this time the light is always
Anxious to be away. The mantel
Brasses flicker and Malcolm Mooney's
Walrus tooth gleams yellow.

Who let you in? Who pressed
The cracked Master's cup on you?
I will show you out through
The Master's door to the Servant world.

Dont let Master cat out.
He has to stay and serve with me.
His Master now must enter
The service of the Master Sea.

My dear The O'Malley,
I send you this copy because you
liked it. It is coming out
in the Penguin book inscribed
in the Irish Gaelic characters.
———— See us soon —
love. WSG. x

Graham's poem dedicated to O'Malley

highly personal visual vocabulary. He still lacked any serious recognition from dealers which, like it or not, meant he had very little income on which to subsist. O'Malley could be his own worst enemy with dealers, it was a curious irony that having spent many years working in banks and dealing with other people's financial affairs, money and art did not mix naturally for him. Dr Slack recalls that O'Malley seemed to exist at this time on a diet of Irish whiskey and anchovies on toast (he was also an aficionado of what Wynter dubbed the 'Blue Smoke School of Cookery'). At the age of fifty-six he still felt very much alone as an Irishman in exile with no recognition in his homeland. For a man who believed he would probably die sometime in the 1960s a new decade dawned in which he would experience a dramatic rebirth in a completely unforeseen way.

1970s

I'm very aware of surface; an area of paint has to have a reality, a tactile presence. O'M

O'Malley was always very popular with women, his attractive and chatty demeanour making them feel at ease. He had many romantic attachments but none had meant enough to break through his essentially introverted nature and distract from his work. However, his bachelor days were now numbered.

Jane Harris had arrived in St Ives in September 1969. Born in Montreal, she had been touring around Australia, Russia and Europe and, having worked as an au-pair for three years in Switzerland, was anxious to pursue a career as an artist. Leonard Fuller's art school in St Ives was recommended to her (where Nicholson remained an abiding influence). She had been painting since, as a child, she did many botanical studies with the aid of a magnifying glass. In January 1970, now out of money and having found St Ives a bit cliquish, she decided to return to Canada. But before doing so she visited a sick friend and there she met O'Malley, also paying a visit. Soon after, on another visit, he saw her portfolio and she found him most encouraging. She was fascinated by his studio and seeing how he worked. She had been aware of his paintings before this, particularly one from the cornfield series which was on show in the Wills Lane Gallery.

There was an instant bond between them, but for the moment, because of a thirty-year age difference, they affected a discreet distance.

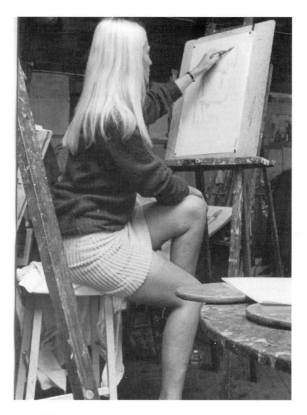

Jane Harris at a Leonard Fuller life class 1969 [JOM]

He and Jane visited Saint Martin's in the early summer (a visit that was to become an annual event), their first painting holiday together. They laid out their paints and crayons in the middle of a small table and worked from either end in silence and perfect accord. Many months before this O'Malley had stubbed his toe, which had gradually festered and was now causing him much discomfort. But, while here, bathing it in the sea offered some relief and it appeared to be on the mend.

Shortly after this Jane paid a visit to Canada for the first time in several years. It was to be the longest period she would be parted from O'Malley for the rest of his life. While she was gone he took the opportunity to visit Clare Island for a month. Here he walked his foot into the ground like a man possessed, and he completed an extraordinary sequence of hundreds of drawings. He later spoke of this experience with awe as though it were

transcendental and claimed to have been taken over by something outside himself; he became a conduit for the island itself with its *genius loci* and all the ancient O'Malley ancestry. He never felt that he succeeded in doing anything like these drawings subsequently.

On his return he was soon brought back to earth when the toe was diagnosed cancerous and required swift amputation. The operation was performed in Bristol. Yet another entry for his impressive and ongoing medical record.

In many of his paintings he was now favouring dividing the picture into panels as if looking through windows or aerial views of field patterns: *An Géimhreadh – Winter Pattern*; *Window I* and *II*; *3 Winter Areas*; St *Martin's Island*; *St Martin's Bird Table* and *St Martin's Fields, Spring* are typical of this device.

In such a small community as St Ives it didn't take long for the liaison between the older and younger artist to be noticed and they were soon accepted as an item. However, to those who thought they knew O'Malley well, it still came as a great shock when, on June 10th 1973, they secretly got married in the local Church of the Sacred Heart and Saint Ia. He was in his sixtieth-year, twice the age of his new bride. A few neighbours were roped in to act as witnesses. Initially they went only as far as Nancledra, to stay in Boots Redgrave's cottage, before embarking on a second honeymoon in Panex, Switzerland for two months (where Jane had au-paired). This was Tony's first time abroad. They did much drawing and walking in the Alps, where Tony really missed having both lungs firing on all cylinders.

At one point earlier in her life Jane had a yearning to be a nurse and there was a sense in which she could now realise those caring skills for a man who had seen more than his fair share of serious illness. She also brought a pragmatism and energy that would invigorate him for another thirty years.

The couple were on the move in 1974 with visits to the Scillies and Jane's first visit to Ireland. A new place breathed new colours into O'Malley's earthy palette when they visited Jane's sister, on Paradise Island in the Bahamas, for the first of fourteen consecutive winters there. For convenience of transport large rolled up canvases were used, this was sail cloth bought in Newlyn, and rolled around plastic drainpipes (a demonstration of Jane's pragmatic genius) and they worked together *en plein air* often using an acrylic applied lightly so it wouldn't crack when rolled up and brought home. The ambiance was also a

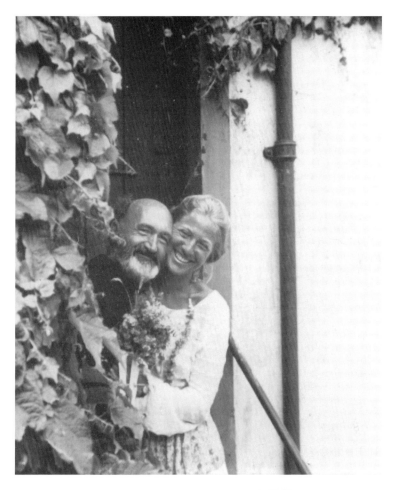

Wedding day June 10th 1973 [JOM]

boost for O'Malley's health. Once again he was well aware of the history of this place with its brutal legacy of slavery. But the people were lively and spirited with voodoo and folk-ways he could empathise with. The painting gradually metamorphosed into lush, exotic flora and fauna under a glaze of shimmering heat. He started painting colour for the sake of colour reaching for a whole new range. As this essay deals specifically with his response to Cornwall the Bahamian work will not be looked at here, except to remark that having flexed his chromatic muscles he would never paint Cornwall and Ireland in the same way again.

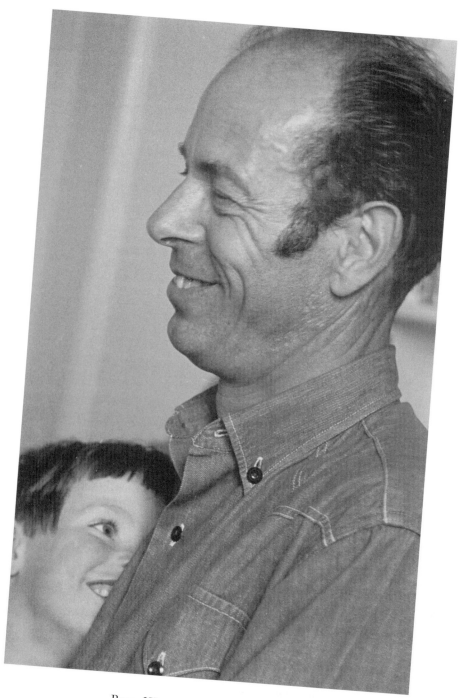

Bryan Wynter and his son Billy [RS]

1975 is remembered as an *annus horribilis* for the St Ives art community, with three major deaths in three months. On February 11 Bryan Wynter had a fatal heart attack, fourteen years on from that first attack when he shared a hospital room with O'Malley. He was a much loved, warm and gentle character and one of the people O'Malley missed most in his later years. Only twelve days later Roger Hilton died, as the result of a stroke, at his home in Botallack. O'Malley knew him quite well though they were never close. He was perceived to be a difficult man and had been on the road to self-destruction for well over a decade (apart from his 500 Woodbines a week he once noted his annual consumption of whisky to be 300 bottles). As usual Sydney Graham rose to the occasion with his elegies *Dear Bryan Wynter* and *Lines on Roger Hilton's Watch*. Finally, one night in May the *grande dame* herself, Barbara Hepworth, died tragically in a fire at her Trewyn Studio. She maintained her own tight circle of friends which O'Malley was never a part of. This year is still recalled locally along with 1964 and the death of Lanyon, as the end of an era.

For the O'Malleys there was some relief from the gloom when South West Arts and The Arts Council of Northern Ireland arranged for a travelling exhibition of Tony's work, taking in Belfast, Dublin, Bath, Truro and Newlyn. Patrick Heron added some clout by writing a strong introduction for the catalogue. Heron, with his wife Delia, had always shown great kindness to O'Malley and regularly invited him (and now Jane) to Eagles Nest. He had a reputation as an exceptionally sensitive and erudite art critic which made it all the more satisfying that he should extol O'Malley's work for the show with such highly considered praise. It may be instructive to quote some of his comments at length:

And the entire pictorial climate is now far more sympathetic than it was to painting which betrays in every square millimetre of the picture surface, evidence of it's having been made by hand...

O'Malley, unlike, for instance, the conceptualists, and unlike too many of the internationally identifiable op or pop or hard-edge painters, actually goes around with his eyes open. He looks at objects – of any or every description; he looks at light; he cannot help all the time consciously absorbing the actual visual nature of whatever reality or scene, or environment he finds himself placed in at any given moment. Hence the thousands of very small drawings, colour notes, texture-statements, which he makes at practically any hour of the day – any day; every day. Hence, too, the enlightening fact that his notebooks switch, from hour to hour, from page to page,

from a great variety of purely abstract linear and colour statements to a host of exceedingly accurate and evocative notations of the actual appearance...

His visual curiosity is like his own particular sensitivity, practically without limitation – at least in the sense that that sensitivity has never confined his work to a consistency of style or idiom which would restrict its basic configuration to a limited formal range.

Despite its low key, chromatically speaking, and despite its almost granular textures, the surface of an oil-painting or gouache by O'Malley invariably glows...whereby we feel that the colour is glowing at us from inside the actual pigment and this gift of producing controlled luminosity in his pigment is something which, in O'Malley's case, extends to the handling of those dull colours – the dingy khaki or grey or near-black he so much loves. His darkest or most muted schemes are invariably *alive with the vibrancy of the born colourist.*

Significantly, the show took in not only Belfast but the Caldwell Gallery in Dublin. This was his debut airing in his home country since first encountering St Ives exactly twenty years before. Unfortunately the gallery could only accommodate about half the works. Nevertheless people expressed surprise at the existence of this previously overlooked Irishman abroad. The tide was turning.

Reviewing the show in Newlyn, for *The Western Morning News*, Frank Ruhrmund had this to say: *The majority of paintings are abstract in approach and style and, while they may at first baffle if not bewilder, it is well worth staying with them for a while, for they eventually bewitch. One soon senses that there is a real intelligence at work here...*

This makes the perceptive point that it often takes time to appreciate an O'Malley work. As he himself said, his paintings slumber on the wall, and the best of them do require a sympathetic participation from the viewer for them to 'awake': the more you put in the more you get back.

O'Malley had a slight scare at the Truro show. It was held at the County Museum and when the artist and his wife turned up to hang eighty pictures there was no one to help with the hanging. After struggling for some time O'Malley had to return to St Ives with an attack of angina and they both missed the opening. This was a recurring problem that required close monitoring. In 1977 the discomfort was serious enough for Dr Slack to be called to Seal Cottage. Despite promising her husband she would not put him in hospital again, Jane realised the urgency of the situation and Dr Slack sent

for an ambulance which took O'Malley to Truro. They were all for sending him home after a few days but Dr Slack insisted he be kept under surveillance. Nine or ten days later O'Malley's guardian angels were on duty when, during the doctors' rounds, he had a massive heart attack. He couldn't have been in a better environment. An indication of the good doctor's foresight.

Dr Roger 'let nature take its course' Slack (as he was affectionately known in some quarters), having served in the navy during the war, had moved to St Ives with his wife Janet, in 1947, where he set up a practice simply because it was affordable. As luck would have it, rarely, if ever, in the annals of medicine can there have been a physician with a more illustrious register of artistic patients. He was highly regarded as a sympathetic doctor, as the many gifts of art bestowed on him testify. He was also an archivist (taping memories of Alfred Wallis by many of the people who remembered him in the '50s) as well as a gifted sculptor in wood and stone, while Janet was an accomplished musician and crafter of jewellery. When, after thirty-seven years of unstinting service administering to the sick, he spoke of how much he was looking forward to retirement, an aghast Sydney Graham, who couldn't comprehend such a thing said: 'But we poets never stop'.

A welcome visitor from Japan around this time was Mihoko Okamura. She had been secretary to D. T. Suzuki the great scholar and exponent of Zen

Janet Slack at Fisherman's Cove 1962 [RS]

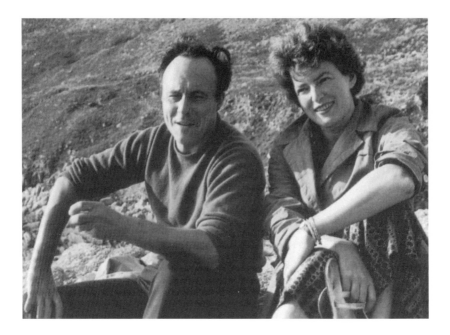

Patrick and Delia Heron, Cot Valley 1959 [FEM]

Buddhism. She came to see Bernard Leach and visited the O'Malley studio, where she recognised a Zen quality in many of the smaller, and often overlooked, works and asked to borrow them for a few days. She did indeed purchase them before returning and startled the O'Malleys by using a pocket calculator, something unseen in the west at this time, to calculate the prices in yen.

1977 saw O'Malley staging three one-man shows in Ireland: Belfast, Dublin and his home county at the Kilkenny Arts Festival.

A labourer's cottage with an acre of land came to the attention of the O'Malleys and they purchased it from seeing only a photograph. It was located at Physicianstown near Callan. They now had a foothold back in Ireland and would spend the summers here; in time cultivating a superb garden and building on studios.

May 1979 brought more than its share of grief when dear friends Bernard Leach and Delia Heron died within two days of each other. In more recent years Leach's eyesight had been failing and the O'Malleys regularly read to him in the evening. He was to leave his sable brushes to Tony. Patrick Heron

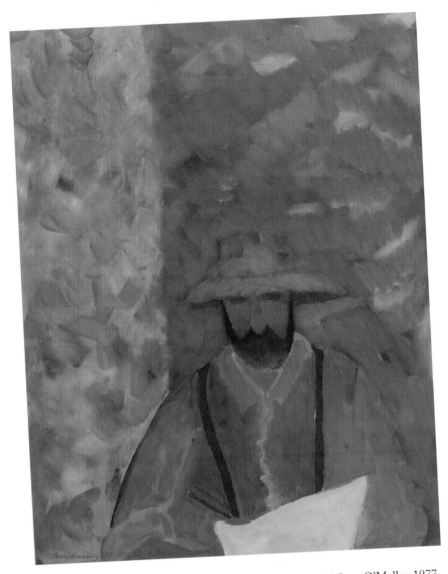

Tony Drawing at Eagles Nest (recuperating from heart attack). Jane O'Malley 1977
28 x 22 in. oil on board

was left bereft and turned increasingly to the O'Malleys for company, particularly in the evening after a day in the studio when he would stop by for a whiskey, a jacket potato and a sometimes lengthy chat, usually about politics.

A large exhibition at the Penwith Gallery brought a remarkable decade of increased recognition to a close.

Part of Bernard Leach letter to O'Malley while he was in hospital in Bristol

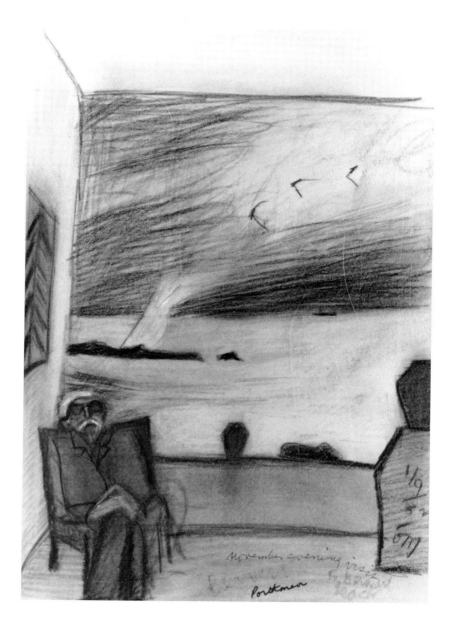

November Evening Visit to Bernard Leach, Porthmeor 1982 34 x 26 in.
mixed media

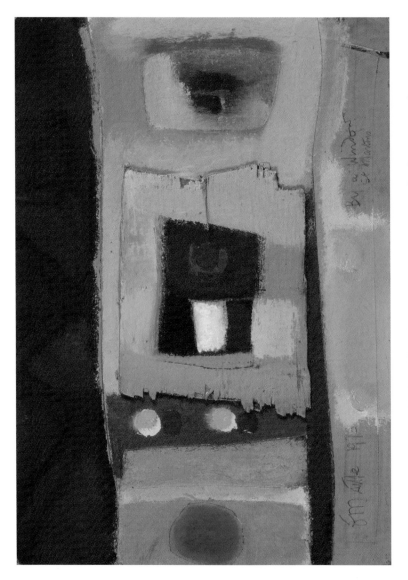

By a Window, St Martin's Island. 1973 10¼ x 14½ in. oil and collage on wood

The O'Malleys in their Porthmeor studio 1980 [RS]

1980s

The poet distils words while the artist distils images. This image-making, this poetry is also distilled in a bottle of whiskey; you can settle for one or the other. O'M

The 1980s would see the O'Malleys spending more time away from St Ives with regular trips to St Martin's, spring and autumn; Ireland, summer; and the Bahamas in winter. Though they remained anchored at Seal Cottage and the studio in Back Road West.

The story so far suggests O'Malley to have been a serious painter dealing with the big issues of the human condition. However, he certainly had a humorous light side, often seen in the drawings and sketches. This sensibility now came more to the fore in the paintings within the context of domestic, occasional work. Friends, relatives and pets recur including his Clare Island cousin Michael Joe and of course his wife, whether knitting, painting, washing her hair, picnicking or whatever. O'Malley's bright, effervescent palette is usually attributed to the Bahamian influence, but this is also the work of a man at ease with the world; the lightness and brightness indicative of a spring in his step and the joy of his marriage. A musical influence was mentioned earlier and the works of the 1980s resemble even more a vibrant melodic score, his light darting strokes suggesting the 'blooming, buzzing confusion' (William James' phrase) of the natural world, in a strange dreamlike way.

The O'Malleys with Janet Slack below the studio 1975 [RS]

However, having had more than his share of close encounters with mortality meant that the *memento mori* of the skull or ghostly figure still put in a regular guest appearance. The Irish have always had a fascination with the grotesque in literature and art, particularly the Síle-na-Gig, and such figures remained a part of O'Malley's stock repertoire. *Calvary, Number* 1 with Calvary, *Number 2* and *Spring Music in the Boneyard*, all 1983 oil on board, are good examples of this as well as *From an Old Limestone Carving, Kilkenny*, gouache on paper. Even if the Good Friday paintings were brighter in colour the subject matter remained sombre.

1981 saw much Irish recognition with an Arts Council of Ireland touring exhibition *Miles Apart*, which opened in Kilkenny. He was awarded the Douglas Hyde Gold Medal at the Oireachtas exhibition in Dublin and was elected a member of Aosdána (an affiliation of creative artists in Ireland).

Awareness of O'Malley in Ireland took a further quantum leap in 1982 with the RTE television documentary *Places Apart*. The film showed O'Malley at work in his St Ives studio as well as exploring Kilkenny lanes, at an alarmingly spritely rate (he was then sixty-nine), on a bicycle with Jane. The film is a good record of the man at work and play. He also had the first of several shows at the Taylor Galleries in Dublin.

In addition, the chief art critic for *The Irish Times* Brian Fallon (son of Padraic) wrote the first serious study of O'Malley in 1984 to accompany a major retrospective exhibition: *Tony O'Malley: Painter in Exile*.

St Ives as an art movement or community was now gradually being forgotten by the world at large. Many of the key figures had died, and it was now seen to be rather provincial whereas it had once been international. In 1985 its reputation would receive a fresh boost with a big Tate show in London: *St Ives 1939-1964: 25 years of Painting, Sculpture and Pottery*. It ran from February to April and generated much public interest. David Brown was given the task of selecting work and for one reason or another it can now be seen to have been a very unbalanced show, a bit top heavy with the big names while several artists were overlooked entirely though they'd been promised inclusion. Brown was sent into the O'Malley studio by Patrick Heron but he showed little enthusiasm for the work and seemed to pick one almost as a token gesture, *St Martin's Fields, Spring* (1972 oil on board). At least he was in. But to this day it is an odd fact that the Tate Gallery doesn't own a single work of O'Malley.

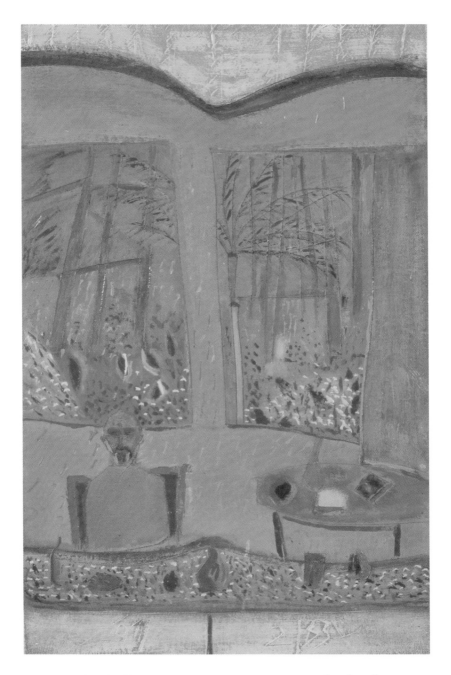

Morning Mirrorscape, Bahamas. 1983 18 x 12 in. oil on board

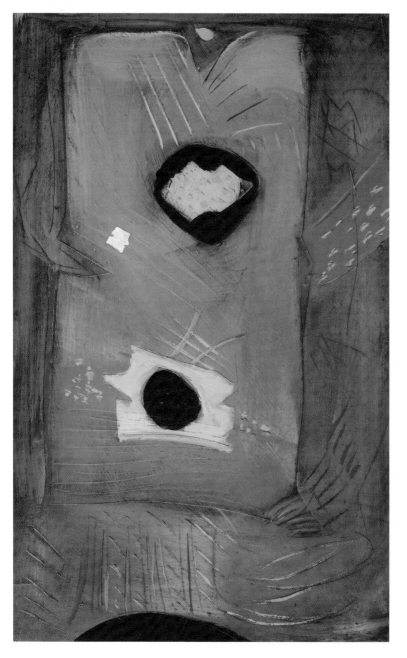

The Worktable and Silence. 1985 15½ x 25½ in. oil on board

With so much gathering apace in Ireland the scene was now set for O'Malley's exile to draw to a conclusion. A fresh generation of enthusiastic Irish artists and writers beckoned and looked to stimulate O'Malley's perennially youthful mind. The O'Malleys' creative energies were now being applied more and more to the development of the house and garden back in Physicianstown.

Whereas in Cornwall most of their friends had either died or moved away and his work was out of step with the times, there seemed little prospect of further success in England. It was while on holiday in Lanzarote in 1989 they made a joint spontaneous decision, having talked about it for years, to return. In St Ives they went about packing things away discretely, over a certain period. On April 8th 1990 they turned their back on the little seaside town at long last. They had no real regrets, it was the right time to move and they had a new challenge to look forward to together.

One last drama lay in wait for the O'Malleys before their final return. They had driven to Pembroke to catch the ferry. While resting in their bunks they heard urgent banging on the cabin doors, Jane went to investigate and was horrified to find the corridor filled with smoke: the ship was on fire at sea. They crawled along the floors choking and eventually made it to the upper deck. Helicopters came to the rescue removing certain passengers who were in a bad way. The ship made it back to the harbour and eventually passengers were taken by bus to Fishguard where (reluctantly in some cases) they boarded another ferry, this time arriving back on the lush *terra firma* of Irish soil with much relief.

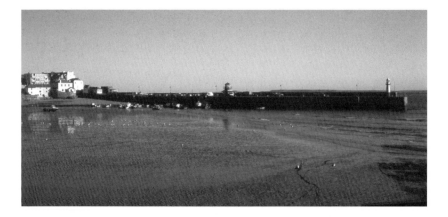

Smeaton's Pier, St Ives

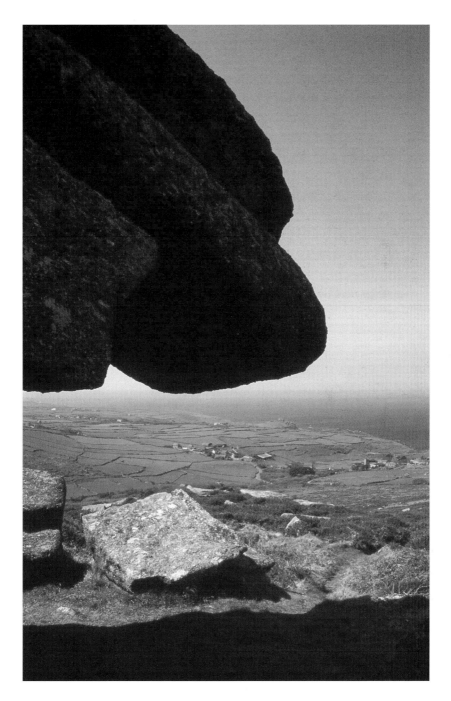

Zennor

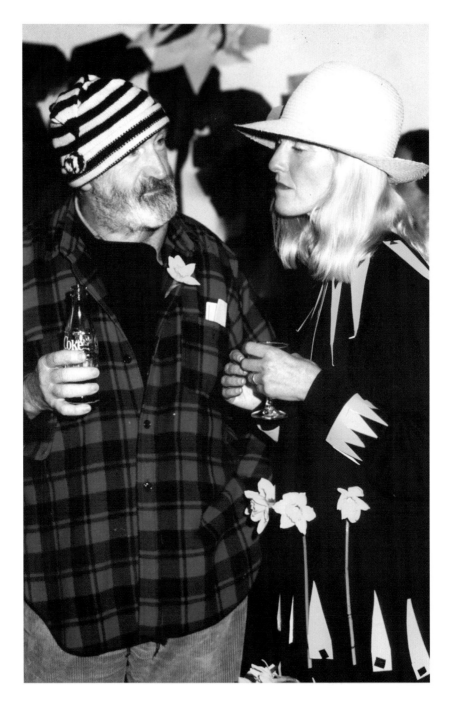

Fancy dress at the Penwith Gallery 1983 [RS]

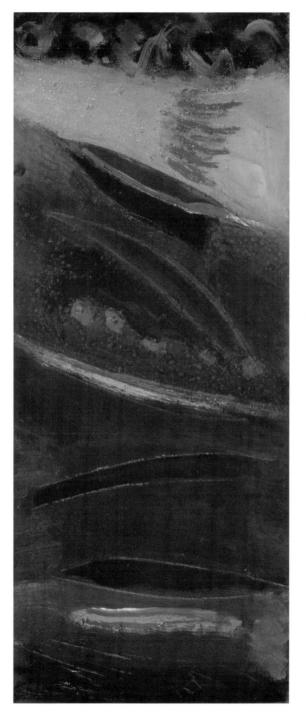

September Painting. 1989 9 x 22 in. oil on board

LATER YEARS
AND CONCLUSION

All my life I have lived on the horizon of my death. Michaelangelo

O'Malley was in his seventy-seventh year and he would now reap a rich late harvest of awards and rewards after so many years of struggle and neglect.

In 1993 he was elected a Saoi (wise man) by the members of Aosdána. The then President of Ireland Mary Robinson invested him with a gold torc, which is kept until death; the previous wearer of O'Malley's torc was Samuel Beckett. In his brief acceptance speech he said: 'I regard this award not just as an honour for me but, if I may say so, an honour for Ireland.' This was meant, of course, in an entirely impersonal way.

1994 saw him inside the walls of a university for the first time when he received an honorary doctorate from Trinity College, Dublin. As Trinity had been part of the old establishment order, this was a proud moment for the largely self-taught Republican.

Finally, another quietly crowning moment was when, in 2000, he was made a Freeman of the City of Kilkenny.

There was more illness to combat and recover from, including bronchial pneumonia (he'd been administered the Last Rites approximately six times throughout his long life, but it was never time to let go).

He continued doing good work and had a joint show, with Jane, of recent carborundum graphic works only a few months before his death.

His last mark as an artist was on Christmas Day 2002. Using an oil-bar, he applied ultramarine deep onto a large canvas entitled *Riddle of the Universe II* which he explained as 'the explosion of an implosion'. He was now very frail with poor eye-sight.

Finally, on January 20 2003, it really was time to let go, and he slipped away peacefully at home with Jane by his side.

True perfection seems imperfect,
yet it is perfectly itself
Lao Tzu (4th c. BC)

The last decade of his life in Ireland saw O'Malley feted as a kind of folk hero. Even if the Irish people didn't always understand the work, the man was appreciated for a genuineness and lack of pretension. Though reassessments will be made over the coming years, his place as a major figure in Irish art history is assured.

This is not the case in the history of the St Ives art movement. Strictly speaking this was never a homogeneous art movement at all, sharing a manifesto say, like the Bauhaus. It so happened for various cultural reasons (particularly the war) that a lot of very talented people came to share a particular geographic location, the Land's End peninsula, at a particular time. Books have been written exploring this phenomenon with a great deal of attention given to the characters involved. However, it is a puzzling fact that O'Malley barely features in any of these studies. Considering that he lived in the area for thirty years and befriended all of the other individuals listed it seems an extraordinary oversight.

There are several reasons that may have contributed to, without excusing, this omission.

Two days after O'Malley's death I visited Willie Barns-Graham for tea.

We sat by her panoramic window overlooking the Atlantic rollers breaking on Porthmeor beach below. In the crisp January sunshine she recalled O'Malley with great fondness; then her voice became slightly more stern and she said: 'Of course he did far too much work, he never stopped. An artist must stop to take stock.' This offers a clue as to a problem some people have with O'Malley. Barns-Graham was very much an academic artist; she was highly self-conscious of where she fitted in, in the art historical scheme of things. She also came from a Scottish puritan background with a particularly severe work ethic. Each work is carefully refined and burnished until it can be neatly filed away as a finished product. Her mentors were Nicholson, Hepworth and Gabo: all very clean lines. This is in sharp contrast to where O'Malley was coming from. He had a simple countryman's background bringing an earthy dross and dung into the studio. He was prolific because, for one thing, being a late starter he felt the need to catch up. Having had so many brushes with

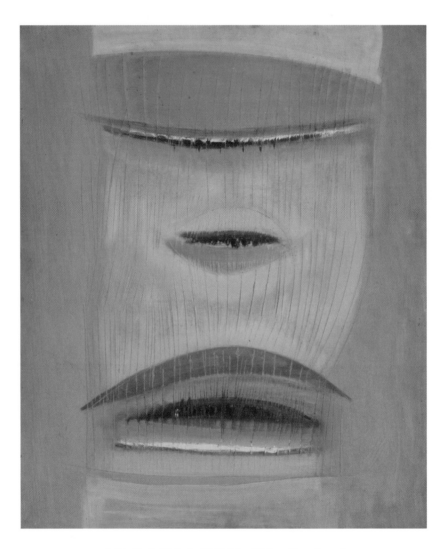

Celtic God of Music. 1968 36 x 30 in. oil on board

death, there was an added urgency: he could die at any moment (he too was a disciplined worker, especially after he met Jane). Hence he was extremely productive, working constantly on anything he laid his hands on. Inevitably he used some inferior materials and some people unfortunately equate inferior materials with inferior art. Much of the work can appear rough and unfinished (but recall the Japanese aesthetic mentioned earlier). Bob Devereux has said O'Malley taught him that a painting is never finished, it is only resting, and this recalls Paul Valery again, who said a work of art is never finished but is always abandoned. Barns-Graham would probably describe herself as a professional artist, it was her job. For O'Malley it was more than a profession, it would be as ridiculous as saying he was a professional human being. It was fundamental to his very being like breathing, and you don't stop to take stock of your breathing. He never destroyed anything as it was all part of a bigger process, it was all relevant, each piece caught a moment on life's journey. As a consequence, there exists an abundant body of work seen to be of varying quality. But this misses the point of O'Malley, it is the wrong criterion. Each piece should be acknowledged as a fragment of the rich tapestry of a life lived to the full.

Having jettisoned his orthodox Catholicism into the Irish Sea, art would take its place as a devotional act for his personal growth. He was profoundly introspective, developing his own intimate imagery with his own personal hieroglyphics (always drawn from his engagement with nature and the history of a place) and it can be difficult to find an entry unless the viewer shares a deep empathy.

Being self-taught can invite suspicions of technical limitations and can act as a blinker to seeing an artist whole. The art school approach likes to see an artist's pedigree displayed, so it's clear where everyone fits in. Such a mind set hasn't got the capacity to accommodate O'Malley's rich variety.

He was an outsider and an original and the people who write the histories like to classify artists into groups and factions and here they certainly have problems fitting him in. It is therefore easier to ignore O'Malley than to categorise him.

All human communities seem to develop some form of hierarchy that involves a competitive power struggle between ambitious individuals. St Ives was no exception to this. There was a great deal of political horse-trading and manipulation going on that could make or break reputations. Certain artists

spent almost as much time in selling themselves and their art as they did in making it. O'Malley had a certain countryman's reserve, a shy modesty underneath a jocular exterior which meant he never pushed himself, and he remained outside this power game. He was cute enough to be aware of it but he conserved his energy for his work. He never displayed resentment or self-pity, there was no time, with the grim-reaper possibly lurking around the next bend in the journey. But this did lead to him being overlooked by particularly important dealers. Although Patrick Heron made some efforts on his behalf, you really have to work at it yourself.

Finally, there is one other important area to take into account. It is highly charged and contentious and comes with several hundred years of harrowing cultural baggage. It involves, of course, the love-hate relationship between England and Ireland. Or more specifically, the experience of the Irish exile in English society and it does impinge in a complex way on O'Malley's neglect in England.

The Irishman has always been seen, for good or bad, as a figure of fun. He is entertaining and witty to have around. Two of the wittiest men who ever lived happened to be Irish exiles in England, they also happened to be acute and perceptive critics of the English class system. But, in their day, Oscar Wilde and Bernard Shaw had a big problem being taken seriously. If you are good for a laugh it confuses people when you show any depth or profundity; they still think you are play-acting. This is part of an ingrained mindset, it may not be that way today, but in the 1950s and 1960s even a liberal bohemian artists' colony couldn't escape it. Ireland has one of the world's great literary traditions and the Irish blarney is enjoyed wherever there are Irish people. But very little is known about its visual culture. O'Malley was perceived as a man without a tradition whereas we have seen that he was well aware of himself as part of a lengthy pagan, Celtic and Christian tradition of visual art that drew from mythology and the natural world for its symbolism and ornamentation. But this was out of step with the modernism dominant in St Ives at this time. If Lanyon had lived his natural term it's just possible that O'Malley may have had another powerful ally in the man he held in the very highest esteem.

Sadly, these are some of the reasons, as convoluted as any Celtic knotwork, why O'Malley isn't always listed with his many great peers. The powers that be have totally failed to understand his inimitable genius. O'Malley wasn't just a

major artist, he was a major cultural phenomenon; this has been recognised in Ireland.

It is now fifty years since he responded to the ad in *The New Statesman*. As fate would have it he did go to exactly the right place at exactly the right time. He found his vocation, he found love and he found himself. He would probably have perished in despair if he hadn't gone into exile when he did. His psyche clearly had a deep, lyrical resonance with the landscape and history of West Penwith and, through the journey of his art, he performed an elemental act of communion with the spirit of this enchanting place.

Zennor

APPENDIX 1

Inscape – Life and Landscape in Callan and County Kilkenny

(from an interview with O'Malley by Willie Nolan and Kevin Whelan for the book *Kilkenny: History and Society*)

My grandmother was a Marnell from outside Callan. Marnell's Cross was called after that family. She was born around 1840 and was married to Mattie Ryan, a gardener in the convent. There are photographs of my grandmother and Dan Ryan (his main companion, although they were not related) standing beside an ass and cart, holding a load of manure. My grandmother's (Margaret Marnell) brothers were active Fenians in the 1860s and they went out to America. Jack and Ned Marnell got away to America and remained there, but came back at different times to visit Callan. Ned was a bit of a scapegrace, consorting with disturbed elements, while Jack was a more orthodox kind of man. Their heroes were John Locke and Coyne of Bridge Street (which was Coyne Street originally) both leading Fenians in Callan – 'The ould Feneens' they were called. James Cody of Callan mill was also one.

My mother was Maggie Ryan, daughter of Mattie Ryan and Margaret Marnell. They were much knitted into the people of the countryside. The Ryans were a big clan of people. They were part of the Kilkenny/Tipperary texture. My grandmother used to say that her family was evicted from the Raheen down near Tullamaine. Tullamaine is an ancient place – one of the great early Christian bell shrines was made there. Because of the eviction, the Raheen became a kind of sanctified place which you went down to and pondered. I was conscious of it, not in terms of terrible violence or vengeance but in terms of stories told and memories. My grandmother was very fair: in a way, she was a socialist. She would not pre-judge a planter or a farmer, only ask whether he was a good man. She admired and was very interested in the Quakers and spoke highly of them. People like the Armitages and the Whites were very fair and distributed the meal during the Famine. One of her close friends was a Protestant, Linda Cherry, who worked in Gregorys of Westcourt. She was a confidante of my mother.

My father, Patrick O'Malley, was a Clare Island man. He was one of a large

family, the children of Anthony O'Malley who was drowned during the time of the land war. After leaving the island, my father worked for the Congested District's Board and then came to Kilkenny city as a representative for Singer Sewing Machine Company. He met my mother who was living in Callan and they married and settled down. My Clare Island inheritance which is more psychic and sea orientated is mixed therefore with the more introverted and land based Norman Celtic heritage of county Kilkenny.

My grandmother had Slievenamon Irish; around here is part of the Decies, which overflowed into Kilkenny. She would say, if you asked her 'how are you?', 'achspleach' not 'neamhspleach'. My mother's sister was the same – she also had many words that were pure Irish. My grandmother talked of the Caravats and Shanavests, who were the factions then. Callan and Ballingarry were laid waste by the big faction fights. The Caravats were related in a way to the Ribbonmen and the lower class of people. The Shanavests were stronger socially. I never knew whether my grandmother was a Caravat or Shanavest but I think she was a Caravat. They were the labouring people. Somebody said one time in a pub in Callan – 'play up the Caravat jig' and there were immediate ructions. Amhlaoibh Ô Suilleabháin was known in Callan amongst old men when I was growing up – he was spoken of as 'Old Humphrey.' People knew where he lived in Green Street. He wrote about the factions. He was the authority, the Kerryman, the scholar: that acknowledgement was given to him. He took the trouble to learn all about Callan, walked about it, met the parish priest and the protestant clergyman. He was a great man of his time.

The schism was the next big thing in Callan, the reds and schismatics. The name 'schismatic' was applied to the bishop's men, the established authority of the church. The 'reds' were the people who supported Fr O'Keeffe, who was a social reformer. Callan was a poor town after the Famine. The bishop and the business people were regarded as 'schismatics'. My family were 'reds'. The word 'red' came into the language after the Paris commune. During the ructions, a picture and notice about Fr O'Keeffe were being nailed up in Callan. An old woman shouted up, as the men drove in the second nail, 'put another nail down there and you'll have him crucified'. I inherited sympathy for O'Keeffe from my mother and grandmother, who regarded him as a champion of the people, against elites, clerical and otherwise – a distant echo of the influence of the French Revolution.

In our young years, we went to the convent up to the age of seven until we

made our communion and then we were trained for the sacrament. We were taken up to the church and the two shilling pieces were put on our tongues. We were terrified, we could not make head or tail out of this. We would be marched up and taught by a monitor or monitoress. Then we were ready for our first communion. We were dressed up in clean shirts, which were a big outlay for people at that time. The girls had wreaths. You presented a candle at the altar rails. There was a fellow below me whose candle was decorated with flowers. It would be lit (we did not understand the full ritual at the time) and the server came along and took the candle and this fellow above me held onto the candle. 'I want me candle', he said. He did not like the fellow who was taking it from him either – the fellow who was in the soutane, so he held onto it.

When I was at school our great rendezvous was Pollard's stables – a place of oats and straw, and the smell of horse manure – a bastion under the edge of the town walls, where a carpenter worked, so there were coffins everywhere. When we wanted our homework done, we would go there, bringing Willie Walsh, a farmer's son, with us, who was good at maths. There would be a bottle of puce ink on the stable window and we would compel him to confront the conundrums, while we circled him, watching him working. We would be clever enough not to be too right, starting right and then going wrong towards the end. Brother Gleeson, a serious faced Nenagh man who knew everything, was our teacher – he was like a detective. One evening, six of us were lined around Willie Walsh, forcing him to do the work. Suddenly, Brother Gleeson's voice erupted behind us 'I see I have the honour of being in Pollard's Academy – the university of West Street.' Another day, a fellow mitcher was in Pollards when he heard his father coming up the yard after him – his father lifted the lids of the coffins and found his son lying face down in one of them. One legacy of the Christian Brothers is that, even still, I always see the man over my shoulder, correcting me.

When I went to the Christian Brothers, it was a big step in education at the time. The Christian Brothers reputation was real terror – they 'bet' it into you. You had to be tough. Hurling was very strong with them, hurling and nationalism. This was 1922, the time of the civil war. One night Dinny Lacey's flying column of the I.R.A. took Callan and blew up the middle arch of the bridge during the night. Somebody put planks across it and my mother said to me 'now look, go across the Friar's Bridge down to the Abbey meadow' (the

Friars had opened their bridge to accommodate the people). Myself and three or four others, nothing would do us but to go across the planks. I slipped in the middle of the bloody planks, fell into the river and broke my arm. An old man on the bridge smoking a pipe came in and rescued me. He took me up and pulled me out and we all went up to school together. This will tell you what the terror of authority was at the time. I was drenched, with my arm limp, and I stood in the schoolroom above and it had to be explained to the Christian Brother what had happened to me. I was like a defaulter of some kind. I was taken up to Dr. Phelan and he bandaged me up and sent me home. I had to go back by the Friary. Then there was great wailing from my mother about doing the wrong thing and going across on the plank – recriminations and character assaults.

My father was away from home at the time. The treaty had been signed and the civil war was on. The I.R.A. at that time were called the irregulars and we knew many of them in Dinny Lacey's flying column. When my father came back, he said, 'there's nothing for it but to take this fellow up to Lanigan of Kilbroughan' (around Kilmanagh). The Lanigans were great bonesetters; both the men and the women were naturally gifted – cattle or human it did not matter. So my father said to me 'I'll take you up on the bicycle.' The bike was the great mode of transport then. There were a few old Tin Lizzies around but they all had been commandeered by either the I.R.A. or the Free Staters.

Just as we were setting out, news came that Michael Collins had been shot in Béal na mBláth. My father had supported the treaty; he was a pro-treaty man and he started crying and, as he pushed the bike all the way up to Kilmanagh, he cried. He was a very emotional west of Ireland man. He loved Collins and thought that he was the greatest – he saw him as one of his own people who had taken on the British and shown them. De Valera had no appeal for him. He had time for Dev intellectually but Collins was the man in the gap. We went up to Kilbroughan – its a long, long journey – and we went into Lanigan's farm, a lovely, comfortable farm. Lanigan was overcome by Collin's death as well. After talking about it to each other, Lanigan decided to set my arm. While I was waiting there, he brought me out to the orchard for apples. Then Lanigan bound me and fixed me up. That was my memory of the Civil War and I was only a few days in the Christian Brothers when that happened. It was an emotional time.

We held the Christian Brothers in profound respect but we were not

foreign to them. They were the same kind of people as us. After all, Ignatius Rice was a Callan man. They understood us only too well and we understood them. We might have a fellow from Kerry who was a walking terror but we understood each other. They were practical educationalists who taught the poor when nobody else bothered. I always stand up for the Christian Brothers, knowing what they had done socially for the people after the Famine. With the Christian Brothers, we did learn. Children were never pampered at that time and we worked at home as well. I helped my mother in the shop when I was a young lad, carrying messages and weighing things like spuds. We were imbued with a fierce nationalism from the Christian Brothers. There is an objective historical side to me but I would also understand the emotional history and political difficulties of the time.

The country and town to me were the one. Countrymen came into town every night then on bikes or carts. Country people came into my mother's shop from the Graigue and Ballyline side, from where my mother's people came. The shop was a small grocery, sugar was filled in the bag – ten stone bags into three pound bags and pound bags. Whenever they got money, they would come in and pay. There were schemes too, small Free State drainage schemes and the Shannon electrification scheme started, which brought in money, when the poles were being erected around Callan. People had more money and everyone was a little better off. Slievenamon was the centre of our world – it was also our song. Apart from Kickham's song, the *Lament for Slievenamon* was there too, the magnificent Gaelic song which I can play on the mouth organ. I learned the music when I was growing up in Callan. Fellows were playing melodeons and fiddles at that time. A mouth organ was a very valuable thing. I had a mouth organ when I was small and a melodeon, so I was away with it. The fiddlers were on a higher level. Artistically they would be closest to the harpers. The pipers were great men. They were not numerous then but they were survivors of the nineteenth century piping tradition. There was a man called 'Up Tipp' who frequented Callan and he played the uilleann pipes. He was a magnificent piper but he was subject to our kind of philistinism. 'Up Tipp' would get drunk and start roaring 'Up Tipp' in a pub – then he took up the pipes (which we always saw as a collection of tubes and sheepskin and a piece of tarpaulin to keep the damp out). He had a strap on his knee and a stick and he would lean back on the stick and play, standing up

There were many travelling musicians when I was a boy in the early years

of the Free State. There was an awful lot of men on the roads and there were women tramps also. There would be beggars calling, looking for a pinch of tea and sugar. Biddy the Witch was a local woman, wearing a shawl, who sang ballads in Mullinahone or Carrick to get a few pence. Then there was the 'Four Pound Man', a cattle drover who walked and trotted after cattle with a stick; he had his own kind of technique. He ran after the cattle, put them into a field for the night, slept in a ditch and drove them on again the next day. Then there was 'Jack Empty' who was a melodeon player, who always travelled with his dog. Jack Empty was Jack Naughton and he was a west of Ireland man. Whenever he came to Callan, my father had long chats with him. Jack was like a walking newspaper – he had all the news. My father would say 'were you through Ballaghdereen?' or 'were you through Claremorris?' and Jack Empty would relay all the news. My father, being a Connachtman, had a terrible pull to the west. The Connacht kind of thing is very emotional. When I am over in Clare Island, I very quickly revert to being a Clare Island man because I am an O'Malley – my cousins and all the people welcome me because of that. In Norman Ireland, people are a little more distant. Jack Empty – the beggarman – was found dead with his dog beside a limekiln around the Kilkenny area. He was sleeping there for heat, when the wind shifted and he got carbon monoxide poisoning.

'Up Tipp' would come to Callan usually on a day in March or April. Up on the hill in Callan on the moat, you would hear the music wafting from the street. It was a magical thing to hear. You heard the pipes on the street, you came down, there was 'Up Tipp' on his stick. Although he would have a good few taken, he did everything very ritualistically, full of respect for himself and his craft – a musician belonging to an ancient race and tradition. He had a leather patch on his knee and would put up his leg on the stick, put on the chanters, then gather the bag under the arm and start by pumping air into the bag. That is the way he would play – wearing a bowler hat and waiter's tail coat that somebody gave him. The coat would always fly in the wind and hang down, but he was a magician on the pipes. We little so-and-so's of the street got behind 'Up Tipp' and would pull the tail of his coat – 'the curse of hell on the whole goddamm lot of ye' he would roar. We never really knocked him down, we had respect for him. His music would not be heard anywhere else at that time. He was playing the old tunes derived from the O'Carolan tradition. By the time we were growing up, music was increasingly convent music,

'civilised' stuff like '*I dreamt I dwelt in Marble halls*'. The old wild feeling – the 'woodnotes wild' – were being lost. 'Up Tipp' was a great man. In order to assert himself, he would have a few drinks, after a fairly good day when he got money. Then in the evening he would emerge shouting 'Up Tipp' – he would let everyone know who he was.

He would stay in a lodging house in Callan for a couple of pence, in the exact tradition of Rafteirí poet. For us, he signalled the arrival of spring – a time of chasing tops in the street, playing hopscotch, and pipers, fiddlers and singers visiting the town.

We had a gramophone which somebody on my mother's side had sent us from America, an old Edison phonograph with the cylindrical records. Our shop would be full on Sunday because my mother (who was a lovely singer herself) would put on the gramophone in the shop and a niece of my mother's, Mary Blake (an American) would control the gramophone, wind it up and put it on. We had '*The moon has raised her lamp above*', '*The lily of Killarney*' and '*I dreamt I dwelt in marble halls.*' Thomas Edison's photograph was on every record. Later when records began to come from America in the nineteen thirties, they were the flat type but still non-electric. That was when the jazz started coming in and that took on like wild fire. Crosby and the crooners started coming then and that became popular straight away too. I understand the pop phenomenon through this; we went for new sounds straight away. The cinema was silent up to 1929. In the cinema in Callan, there was a woman playing the piano during all the dramatic moments and fellows cheering and shouting saying '*Look out, Jaysus, look out, he's coming.*' Cinema was a great adventure then. The talkies were a revolution. Al Jolson's *Singing Fool* overwhelmed the whole place and then later John McCormack (who had a world reputation) starred in *Wings of the Morning*, a terrible sentimental thing. Even the priests bowed before it.

We had Gaelic League dancing in Callan in the town hall and our musician was Tom Funcheon from West Street, a real magician on the melodeon or the concertina. Then we learned all the Irish movements in dancing and Irish itself at the same time. One of the finest men for the Irish movement was Diarmuid O'Bric, from Clochán in Dingle, an absolute gentleman. He helped you speak Irish without any compulsion. Diarmuid was one of the grandest. In the Christian Brothers, we learned Irish because it was *Slí an Eolais* – a page a day. You had to do it. The Christian Brothers were genuine about it too. They were

proselytisers, changing the people over from the terrible nineteenth century, when they had nearly lost themselves.

Callan to me was people, characters and talkers. I used to see the town itself from the top of the Kilkenny road in the wintertime and Slievenamon away off in the distance. That was Callan then; it was a physical place. I saw it as a unit but I knew there were internal differences. I knew the streets – Green Street, Mill Street, West Street and Bridge Street – each of which had its own character. Callan people were observers and if they had something to say, it would be very short. They were full of great sayings. The cross was the unifying place for north, south, east and west – that was the centre. In the days when the confraternity was in full swing in Callan in the twenties, the cross at the four corners would be full of men, each street gathering there, because the pubs were shut (no pubs opened on a Sunday that time at all). There would be men in from the countryside too and men from the west side. A hurling match would also bring them all together talking. You would hear a fellow shouting 'Up Lowry' at three o'clock in the morning, or 'up Neddy Doyle', or 'Up Mooncoin'. That was life then.

Class structure derived from agriculture; farm labourers were aware of being apart. They were probably in a way Whiteboys, without knowing that they were. In their minds, they were men dispossessed and poor. They accepted the fact that they were a labouring class of men but, once they discovered a way out, they were gone. At that time, there was really no way out. Fellows left school at twelve, thirteen or fourteen: only an old fellow like myself stayed until sixteen or seventeen and did the intermediate. There was an acceptance of the fact that you had to get out and earn a living – they had no time for long study. A great many very brilliant young people never achieved their potential because of this.

Callan was a very introverted town, like many others in Ireland. I was able to read such towns because I was a small town man myself. That was interesting to me as a travelling bankman. Through Callan, I could read Buttevant or Charleville, Arklow, New Ross or Kenmare. I could immediately latch on to parallels with Callan. There was a professional class there – there was a man going to university – there was a man who had got a customs and excise examination – he'd be exalted. You would read it all in that way.

I travelled around Ireland as a bankman so I had a great insight into both the small town and the countryside and all the life and tragedy they contained.

You were transferred by bus, with the bike tied on top of it. You had just a cardboard case – the average Irishman then had one suit. You got off at the station and wheeled your bike, you would get word where to go for lodgings from your predecessor. We were the post-treaty generation of Irishmen, who suffered from desperation and lust. The culture then was respectable, decent, repressive. There was a tremendous suffocation. For courting we had the 'Ballroom of Romance' syndrome on a higher level. The great venue in Wexford was Adamstown hall – the money went for parochial purposes, money generated by Guinness and lust! Irishmen of that generation did not fall in love – the average bankman of my generation was unmarried. They were close to the generation of matches, but no new mechanism had taken its place. We were not fully aware of love, and we had a strange view of women. For instance, if there was a barmaid in town, a lot of men would go to the pub just to look at her, but our relationships with women were always indirect, always of the imagination. Our post-treaty generation was soaked in piety. There would be an E.S.B. man, two or three bank clerks, a few girls in the post office, a couple of girl teachers, all in the same lodgings. I belonged to a nomadic society – guards, bank clerks, warble fly inspectors. I would be painting and suffering their criticisms every evening – and they were never short of opinions. The first question asked always about a painting was 'where is that?'

There was courting too at night, great work going on in the ditches, just like in Brian Merriman's poem – hot work in the ditches. It was never spoken of but done instead. The erotic we did not know about at all except that it was something to do with the classical Mediterranean. To us it was a necessity – a nod and a wink to a blind horse – and most of the horses were blind then.

There was repression: the word sex was hardly ever mentioned. There were jokes (not really dirty) of the lower sort, hints, winks and innuendoes. Even the dancing was safe – Irish dancing was regarded as chaste. At the same time, if you fancied a girl, you would drag her close into you and dance around. Generally the people who did not go to any of these things knew the truth and they got married earlier. Many of that generation did not get married at all – I did not marry until I was fifty-nine. You did not get married because you had to have a salary that would give you a certain status. The others who had not to worry about a job and salary were not deprived, they just fell in love and got married straight away. The poor people of the countryside did not give a goddam about who had what – they fell in love, married and had dozens of

children, with nothing in front of them but emigration. Yet, they were not worried about it – they were a really wholesome down-to-earth people. I was down in Clare in 1934 and they had the same carefree attitude – falling freely in love and having a grá for a woman.

The thirties were poor. There was a world recession, much worse than the one now, and rampant unemployment. When I got a job in the bank, an old woman in a shawl (my grandmother's friend) living up at the top of the town in Haggard Green (on the way to Ballingarry, a big line of small houses) came in to see me. She looked at me and gave me a blessing. She was a literate woman and gave me a copy of the *Imitation of Christ*. She said 'you won't read it now but read it sometime.' Would you believe it, years afterwards in the sanatorium I began reading it and I loaned it to people around me. They had never heard of Thomas A Kempis at all. So I wrote a kind of truncated diary on the back covers – 'transferred to such a place,' and I still have it now.

Francis McManus wrote an important book about south Kilkenny – *This house was mine* – a strange, lonesome, introverted book. I was always fond of novels that reflected that mentality, as I always felt their truth. I think there is a melancholic streak in our nature. I always felt Callan. The landscape, whereas it was always visible as a physical thing, was really feeling. I saw it through feeling. I remember going up to Mullinahone with my brother, Mattie, about thirty-five years ago. I had just gone back to work and had a car. We drove up to Mullinahone on a wet Sunday in November, a profoundly depressing day. There was a galvanised gate somewhere, painted red and, as an artist, that struck me – the red gate brought the whole thing alive. Mullinahone itself was buried inside in the pubs talking and muttering to itself.

For a couple of men in Callan, I know that their very silence is saying something – there is a silence in the countryside where people do not move out. I retain an image of people talking behind their fingers in the pub. There were no women in it at all. In Callan, in Bridge Street was Paddy Funcheon's pub (now the Ramble Inn). The men who came in there every night were men from that side of the town, reminiscers, talkers, tracers. When I would come in, they would be looking at me and they would fit me in and talk away. It was very quiet, no shouting, people did not like singing. Up in Killenaule the other day, Jane and myself went into a pub for a quiet drink. There were four or five men there, all muttering away. They stopped when we came in and then they were looking at me – 'the oul fellow with the beard with the young one,' I knew

what they were thinking. They knew. We knew.

Drinking patterns now are not like the old ones. The older style was a reflective pint, a Myles na Gopaleen pint. You lifted it up like a chalice, you'd look at it, you'd study it. If you wanted to say something, you'd leave it down again. Everyone looked at you as much as to say 'when is he going to drink it?' Then you'd take it up again, stop, look at it and then start talking again … 'be Jaysus I'll tell you now.' Mattie and myself used to watch them years ago – certain characters who were going to drink a ball of malt and a pint. It took them at least ten minutes to get around to it – it was a kind of obliquity. The pint would be lifted, then left down again untouched. First of all, the whiskey would be lowered, after making a terrible face at it – a man had to be a martyr – a real martyr – to drink it at all! Then the pint would be lowered down on top of it – but the pint had to be considered first. It was a great ritual. The pattern of drinking revolved around conversation. But you could get a profound silence too – a man disturbing the peace would be noticed. When I was in Irishtown (New Ross), if you were with a Ross man, they invited you into the kitchen. That was a great honour – being brought into the kitchen and made sit down.

I think that the Callan character is cool, detached and observant, a few words here and there, with an underlying reticence. They are always watching and looking. In Amhlaoibh Ó Súilleabháin's diary, which I have read, it was the same – the people, the articulation was the same. Their articulate side is still there; they could say what they wanted to say in a very few words without any ornate dressing. They still remain to be plumbed; they are silent, they drink, they look, observing a kind of inward silence. But they would drink heavily and that evoked a rumbuctiousness in the people, out shouting on the street and that class of thing. In a Callan pub, you would get a man talking, he might say a few words – someone might answer him, the conversation would die away and then a profound silence descended again. Callan was a feudal town, a walled town, which explains its quality of interiorness. Callan is always with me as a strange texture of memory.

I would like to be able to put words on the Kilkenny/Tipperary texture. I think it hinges on hurling and skill and competitiveness, things that are endemic in our people. It is never political in a broad sense but district-localised – 'put up a good man and we'll put up a better man against him.' When I was a boy, Moycarkey and Tullaroan were the great protaganists in

hurling – Toomevara were the *Greyhounds*. If I met a Ballingarry man in Cornwall, we would have plenty to talk and laugh about because of our shared crookedness or contrariness. We are a contrary people – hard to be bested. Kilkenny people never get into a frenzy. The Anglo-Norman conquest in Tipperary and Kilkenny particularly was very thorough. Kilkenny is one of the real feudal cities of Ireland. It has the manners and the customs of a cosmopolitan place derived from a people who are the Irish burgher class. The Banims, for example, were refined writers, civilised men, objectively looking at the society of their time and observing the countryside. There is another side to Kilkenny – the fact that it was a walled town. The hurlers I feel were outside the walls in the Irishtown as were the fiddlers and bagpipers. They would lodge in the Irishtown, coming from the Lord knows where.

I was always a great pro-Wexford hurling man. I had a long association with Wexford, the Rackards, Paudge Kehoe and Nick O'Donnell. But Wexford hurling goes back long before that. When I was in Clare, Tom McCarthy and myself sent for hurleys one time. What came back were the Wexford hurleys – narrow bosses and big heels for ground hurling. They were heavy hurleys actually but they could send the ball flying along the ground. The different counties had different styles, you could see it even in the way they walked in the parade. The Cork strut was there, Tipperary and Kilkenny had a kind of lope because you could not get them into proper marching order – each man was on his own, catching the hurley in different places, a bit embarrassed about having to go through all this. The Claremen were quite aware of themselves, coming from west of the Shannon; the Limerick men led by Mick Mackey – they were proud as hell. I remember seeing an All-Ireland between Cork and Kilkenny who had the marvellous Lowry Meagher. Lowry Meagher in the parade was trailing his hurley, really dragging it along the ground, with a cap on. How he hurled later on! It was the performance itself that mattered not the preliminaries. Tipp men are not great men to parade – it is like waiting for the battle. Wexford men are proud – they walked in a proud way, conscious of being the men of '98.

There is a strong kind of fibre which is in us and survives in hurling. I would hate to see hurling dying; I relish all the antipathies and all the rivalries because that is the life blood of hurling. I would hate to think that a district in a hurling county would not be able to field a strong hurling team anymore and that you would not have more young men out on the quest for fame as hurlers.

Hurling has to do with heroes – 'I'm as good a man as I was last week' – it is a test of strength, character and skill. It is much more important in Ireland than in England. The whole character of hurling is in Sean Keating's painting *A Tipperary hurler* – the way he is holding the hurley, ready for combat. The glint of many Sunday battles is in his eyes – a remarkable study of the type of man who is a hurler.

Hurling is a kind of therapy – a controlled way of expressing the combative side of our nature, a slow valve releasing the tension. There is also a tribal element in it, which carried it beyond sport. If neighbours were playing like New Ross and Tullogher, there would be a real needle in it. It is a different approach to sport than the English have. When Carrickshock were playing, I once heard an old man shouting with a tremor in his voice 'come on the men that bate the tithe proctors.' There was real fervour in his voice; it was like the Matt the Thrasher scene in Knocknagow. It was a battle cry, with the hurleys as the swords, but with the same intensity. The camán now is a very refined thing. In the days when fellows made their own hurleys, they made weapons – these were the cromógs which we made out of black sally (because it was hard to break). It was very narrow, however, and a foot longer than the modern stick. I was a handy hurler, like any youngster reared up in the streets. I had the Christian Brother's style of hurling – pulling on the ball first time. Rising the ball only held the game up. I played left half back and loved hurling.

All of the epic elements inherent in hurling were present in the magnificent 1939 All-Ireland hurling final between Cork and Kilkenny, at which I was present. During the match, it was announced that the Allies had declared war on Germany and a ferocious thunder and lightning storm broke over Croke Park at the same time. But the hurlers were immune to both war and lightning and played in a frenzy – a welter of excitement and passion washed through the stadium. As the wonderful flashes of play were punctuated by the lightning, and the soaked, surging crowd continuously cheered the Homeric bouts of hurling. Jimmy Kelly gained victory for Kilkenny with a last minute point. I was working in Monaghan at the time and I remember vividly the eerie journey north, as the lights went out. We searched dark Dundalk to find a pub and, when we finally did, we celebrated Kilkenny's win by guttering candle light – contented Kilkenny hurling men, although the shadow of a World War hung about us everywhere.

This localism was a Celtic, not an Anglo-Saxon thing. It is difficult to

betray the local instinct when it comes onto a bigger platform. Even if you think of the rivalry between Kilkenny and Tipperary in hurling, there is a unity there at certain times. At the same time, there would be a jab and a jibe, so you would not be 'elevating' yourself too much.

My father was a very pragmatic man. He loved the idea that Irishmen so long under domination were getting a chance. The Irish were up at the top and that did not just mean in America. He knew the business and political acumen of the Irish in America would come up trumps but he really admired their success on the British administrative side. He liked the existence of the British commonwealth of nations – he always said it was the place if you had brains. 'They won't worry who you are, they'll take you on and give you a job'. He loved that idea. He would love to hear some woman come in from the country and say 'Maggie so-and-so's son is after getting a job in the Indian Civil Service.' My father would love that – 'My God,' he would say, 'isn't that wonderful,' and if somebody said 'what's so wonderful about it?,' 'do you realise,' my father would say, 'that that man is going to govern a province in India that is bigger than Britain and Ireland put together.' Long afterwards when I was reading Horace (who was a civil servant, a poet and a Celt from the Po marshes) I found that he had exactly the same idea about the Roman empire. My father was a treaty man – he accepted the treaty because he was a great admirer of Arthur Griffith and Cosgrave.

To my father, being a west of Ireland man, mysteries were there and a mystery was a mystery. Then there was a practical side to religion. He would not be bothered listening to a lecture on the Trinity. I get that same trait from my father. He had a couple of friends who were priests, they played cards but never discussed religion at all. He always referred to it as 'Latin Christianity.' The west of Ireland men were more pre-Christian, more early Christian, more Oriental – like the hermits. They felt religion not as a form but as something magical, curative. My father was not anti-clerical but he saw Catholicism in Ireland as an authoritarian regime, contemporaneous with the British one. The new free state one was as bad – censorship and the devil knows what. The early Free State was a holy terror. The border was a terrible sin against the country, inflicting a long lasting misery.

I did not really know what religion was at all, none of us do. It was the mysteries of religion. I remember saying that the tabernacle might contain a nucleus to a physicist in England and he said 'you're right.' I said 'it's more than

that, because you'll break that nucleus down but I want to go beyond that again.' I have a feeling for the pantheistic world, the world of things, animals, people and places that happen around me. I like to give it an imagery in painting although I could not presume to do it all the time. I try to get underneath what is called reality to the underlying appearances. For me, the religious impulse includes burials, graveyards, stones, and everything like that- the whole godamn lot and godamn is the word. If somebody gave me a neat solution for it all, I would not accept it. I would still have to have the bubble on the pot, the ferment would have to be there, ever-changing. This is a Celtic feeling.

In St. Ives, I met Japanese philosophers and artists and I found that I had much in common with them. We understood each other. Religion was a full institutional force in the psyche of reverend mothers and priests, so much so that people outside found it difficult to comprehend. I was never able to understand formal religion. To me everything was endurance. The brothers and nuns were so sure – that was a very, very strong influence. It means that you never consulted them because consulting them itself would be regarded as an act of weakness. It was left to yourself. My father was an example of an island man – a west of Ireland man belonging to the Gaelic culture. He just looked at them all, as an outside observer, and went his own way.

An American, who was a philosopher and is now a Tibetan monk, gave me a book – *Introduction to Metaphysics*. The title put me off initially but the first line made me read the whole book. It said – 'Why is there something rather than nothing?' – a question that cannot be answered. I was like a greyhound after a hare that cannot be caught. That is the way I look at life and so I read the whole book: it described the Greek Parmenides and the question of being. What was being? What is now? What is going on in the house here? Why are we here? All these things to me are the wonder of being alive.

The bean sí or the bean caointe (the 'bow') represented one side of two different female principles. In the Callan of my youth, the bean sí often left her deadly comb out for some poor unfortunate to pick up: she then haunted his house looking for it back but the only safe way to return it to her was on the top of a red-hot poker, passed out through a window. The bean sí was the cold, inhuman, threatening, austere female, personified in mythology by the moon as a female deity – as opposed to the masculine sun. The moon represented a magical female principle for both the Greeks and the Irish, the great reflector which influenced artists, poets, women and lunatics. My friend Padraic Fallon

wrote about the pitiless female principle, the moon deity who gave birth cold: 'Kore or the moon has no pity' whose influence created 'lunatics shambling on the wrong side of their shadows.' The other side of the female principle was the earth mother in both Ireland and Greece – warm, caring, fertile. She was Demeter, full of care – have another suck of the tit and all that.

These two principles were there in Catholicism but in a suppressed way. They mattered most to ancient people, who really felt it. I was conscious of it too in an unfocused way. Later I discovered the word pantheist and that is what I am, a man not transcending but understanding the ancient forces that are inside religion. I have a strong sense of the ancient forces. If someone was to ask me 'what represents your God at the moment?' it is that ash tree outside the window. When I wake up in the morning, it is full of small birds but magpies drive them off from the grub. I see all these things and I share a sophisticated wonder at these elements. Children have it too, before the school system kills it. I think there is an amount discoverable outside of what we call the school system.

We implicitly believe in the spirit world. There used to be a story about the headless coach of Newtown. A man 'with drink taken' (there would always be an anti-drink motif in these stories) was passing there. A coach stopped and a voice asked him 'Do you want a lift to Callan?' He looked up and saw only a hat and a big vacancy, and the coachman's coat with the collar up. We were also familiar with the mystic Abbey well, which was always bursting into bubbles. It had a sandy bottom. As children, we sat on the wall, chanting 'Holy bubbles, come up to me.' There was a legend too of a head in the well.

I saw two different styles of sculpture in Tipperary and Kilkenny; one was by the old Irish, pre-Norman monk-artist who was more pagan; then you had the Norman artist, who, though more controlled, still had a streak of the pagan. For example, when I was up on the Rock of Cashel a couple of years ago I saw a very big Síle na gcíoch (Sheela-na-gig) which had not been rooted out or buried in the graveyard there. In Kilkenny, we were caught up in an early system of the Pale. In Clare you still had a wilder, freer, less restrained feeling, reflected in the music and house dances. In Kilkenny, the wild note is under control, except when tempers fray in a pub or at a hurling match. In the west of Ireland, you had greater feeling between people. Death knitted them together, for example. Yet, even in Kilkenny, the old Gaelic stock never really lost their inner force, even though submerged.

The Normans as an administrative and warrior class were supremely successful. They were psychologists as well; they had the same attitude to people who were going to be subject to them as Julius Caesar. They saw the Irish as a people to be conquered, administered to, more or less tamed. In fact, they ended up joining them. Take the Butlers and Fitzgeralds – they were Norman but they eventually fused and intermarried with the Irish. The English overlords were worried about that – they said 'We'll never conquer Ireland if these people are going to join the Irish.' I would see this fusion of the two races in Jerpoint, established by the MacGiolla Padraig.

Some of the sculptures at Jerpoint are like English/Norman sculptures in the period after the Norman conquest, especially the effigies. In St Canices, there are knights, canopies, swords and their wolfhounds. That was in Ireland but it was never Irish culture. The O'Tunneys were sculptors working all around this area here, and up into Tipperary, for the Butlers. They were brothers who signed their sculptures and they must have been very interesting people to know at that time. They were native Irish men of great skill. I felt their influence in my own work. I dedicated a painting five or six years ago to them called 'Calvary after Picasso, Grunwald and O'Tunney.' Their calvaries had a common denominator. The O'Tunney's calvaries had all the symbols of the crucifixion in abstract form.

Their work is in Callan also. In drawing a skull, the O'Tunneys drew a rectangle, two ellipses, an oval vertical and then just a grin. That was simply powerful. Picasso would have been overwhelmed if he had seen them, they were so abstract. Our idea of painting now is exactitude of description, but these fellows had a power over abstract forms. They drew a hammer, it was carved in the stone, it was still a stone but it was a hammer – it retained the two qualities. It was not an ornate hammer, just a hammer and a nail and a crown of thorns. They understood stone. So too did the O'Shea brothers from Callan, who carved the witty animals on the Kildare Street Club. I was a friend of Seamus Murphy and Seamus knew all that too. Seamus, being an Irish sculptor, was direct. He could not bear any kind of sentimental stuff. He travelled around also, had his tussles with parish priests about money, a real Corkman.

Power over abstract form was part of Celtic art, because the Celts philosophically did not think that a description of a thing was the reality. The descriptive thing to them was fraudulent: the image, the symbol was the truth.

That was the way they looked at art, which is summarised well in a Chinese saying:

> 'I would not seek descriptions, mere semblances of things
> That art is best which to the soul's range gives no bounds,
> Something beyond the form, something beyond the sound.'

Braque, a French painter, observed that a painting was a mystery, it was beyond. You could analyse it but it escaped you, like a line of poetry – it was always something beyond. In Keat's poetry, there is a line in *Ode to a Nightingale*.

> 'charmed magic casements, opening on the foam
> Of perilous seas, in faery lands forlorn.'

You are puzzled by it but you carry it with you through all your life – that is poetry.

Many years ago a book was written on the *High Crosses of Western Ossory* by Helen Roe. Ahenny, Kells, Kilree and Killamery were a family of similar sculptures. As well as religious motifs, they also depict hunts and chieftains. There are many crosses in this area because it was stone country and border country. These crosses were disturbing and strange to me, with cattle grazing amongst them. My generation was reared up on holy pictures, yet here were powerful, primordial images. In Jerpoint, the apostles are carved on a big stone. There is even a comic side to them, which I thought was good. There were no heavy, ornate trappings, just men doing a job: in the effigies, women are lying down beside their lords and they are as powerful as their lords. I found it disturbing, attempting to reconcile these stark symbols with the awful sentimental images of the Belgian and Italian saints. Here were these craggy truths in stone and they disturbed me. I wanted to draw them. I went and did draw them. I drew Cantwell Fada down in Kilfane – they buckled his legs to fit him into the stone. At least that is the way I read it because he was a very long man. To me these were figures locked in the landscape: the image of something achieved by an ancient artist embodied the landscape itself in my imagination. The Chinese understood landscape as symbol and so do I.

As an innocent in the countryside, I was intoxicated with the hills and the fields. I saw the carvings in Jerpoint as fixities, the spirit was fixed and remained potent and the magic of it was in that stone of the twelve apostles. They are full of energy still but it is the energy of the mind that made them –

the stones are still alive. When I find anything that is alive, I just say the music, the tune is right. I devote a lot of feeling and thought to music, which to me is important. Energy is constant and fixed; all men and women try to collar it but it is there all the time as a constant. That energy pulls poets, artists and writers away from themselves into another world.

I have many drawings of Cody's mill in Callan – mills were my studio in many ways. The whole countryside was reproduced in the mill for me. The town and the country came together at the mill. My grandmother used to get a present of a 'bag of male' (meal) from Cody's mill for to make praipín. You needed fresh ground corn, which you got from a hand quern. A tongue of a boot folded kept the quern at the right level for grinding, which it did into a pint tumbler. You could revive a man directly with a bowl of praipín – it was pure energy. You needed ground oats, warm milk, a spoon of brown sugar and a good shot of whiskey. It would revive you immediately – it was great for exhaustion. The '98 men carried corn in the pockets of their frieze coats for this reason.

Mills were my first love. They represented antiquity, going back to the Normans and the monasteries, like the salmon weirs. I was tremendously elated by the big mills, like Kells, Thomastown and later by the lovely old cornmills in the Enniscorthy area – like Browne's mill of Old Ross and Kilcarbery mill, and Lett's big mill wheel in the brewery in Enniscorthy. Miils were part of an ancient cycle – farm, grain, food, brewing, work, and sun, vital to the whole people. I remember corn going to the mills – the bags, the weighing, the ground corn gushing down the chutes. There was a mill at the end of our garden in Callan. I loved its solemn growl as it started up. The mill to me was a life centre – a centre of food and culture. Forges too were important to me. There were three in Callan – Buckleys, Jim Hickeys (a Mullinahone man) and Philly and Johnny Byrne's. The forge was another academy. We spent our childhood looking at the sparks – There would be men sitting on the hob, talking as they waited for horses to be shod, or a wheel to be banded.

Callan and county Kilkenny influence me in my paintings. It is a quiet influence, no great exhilaration or ebullience about it but a feeling of the deep reality of it. Although I have lived in Cornwall for thirty years, my home place and its landscape is still in my psyche. I call it inscape – inner revelations of the outer psyche.

Jerpoint Abbey

APPENDIX 2

Selected comments about O'Malley

Much of the material given to me in interviews has been integrated into the narrative; but here are a few more personal quotes to convey the flavour of the man.

I think he was very happy here in Cornwall; people were very nice to him and they still talk about him with great affection, nearly everybody loved Tony.
I used to go to his studio just to keep an eye on him. He'd get out his sketch books and flip through them and I'd say: 'Oh that's nice Tony' and he'd peer at it and say: 'Sure that's a lovely one' and tear it out and give it to me! So it became difficult; I didn't mind having them but I didn't like to take them either. Roger Slack – GP for St Ives 1947-1984

He was an enormously loved man. You would nearly fall off your chair laughing at his stories! He knew so much about so much. Tony was uncomplicated, but he wasn't simple. Wilhelmina Barnes-Graham - Artist

At first his work was small, grey and quiet and got overlooked by the loud boys. He wasn't one of the loud boys, that was the thing. He wasn't political in terms of promoting himself; a modest man who didn't want to talk about art. Now, there's a difference! Bob Devereux – Artist, poet, librettist

He was so equable he'd get on with these difficult people, he always saw the good in everyone. People were better generally having him around. I've seen people who were nice in Tony's company who were anything but nice outside it. He didn't get involved in art politics at all, he was an outsider.
Brian Fallon - Critic

'Tony wouldn't knock anyone, he was a most generous man, he would only have something positive to say, he was always positive about other people. Years ago I asked him to give a lecture to the Contemporary Irish Arts Society, he was such an interesting man I thought: 'God they'll all love him', but he said: 'Pat, I wouldn't like that; is it alright if I talk to you about my life and art and you can tell them then,

you can give the lecture?' He was brilliant in a one-to-one or three or four people, but shy in a big crowd. I suppose what the stimulus for me is his incredible charm, real modesty and a huge intelligence, a deep love of Ireland and Irish culture. He had an elephantine memory of Ireland's past. Even though he could settle in Cornwall and make good friends with the people there, he always said to me he was determined to die in Ireland. Patrick J. Murphy – Former Chairman of the Irish Arts Council

A great thing about Tony was his awareness of the dangers of the ego. He had the most complex and subtle mind, he was one of the best talkers I've ever met and was one of the most interesting people I've ever known. In many respects he was the most outstanding Irish mind I've ever come across, incredibly well read. Brian Lynch – Poet, playwright, novelist

Tony's paintings have a completely instinctive and natural lyricism. Bryan Wynter was engrossed by Tony's Irish charm. Bryan had an intensely inquisitive mind and Tony fed him with a particular sort of Romanticism. Jeremy Le Grice – Artist

A musical interlude 1979 [RS]

Botallack mine

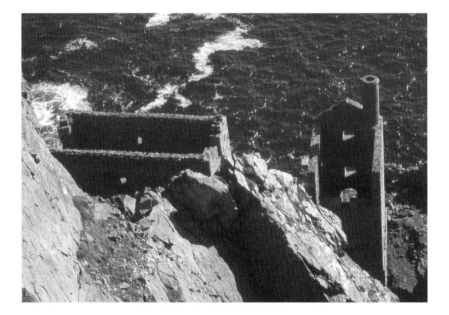

[RS]

SELECT CHRONOLOGY

1913 Born 25 of September in Callan, Co. Kilkenny

1918 Starts at a local convent school before attending the Christian Brothers

1934 Joins the Munster and Leinster Bank. Stationed at Ennis, Co. Clare

1936 Father dies

1939 Moves to Dublin branch (Grafton Street), then Monaghan town

1940 Joins the Irish army, stationed in Dublin. Suffers severe TB and is hospitalised

1941 Discharged due to ill health. Returns to the bank and begins a peripatetic life serving in Co. Kerry as well as Limerick and Dublin

1945 Sent to St Vincent's Hospital in Dublin for major lung operation. Paints his first oil painting while convalescing

1946 Bank stations him in Wexford town

1947 Further lung operations in Dublin

1948–50 Convalesces in Kilkenny and Dublin; painting and drawing steadily

1951 Bank transfer to Enniscorthy, Co. Wexford. First exposure to the public at the annual Irish Exhibition of Living Art and the Oireachtas Exhibition.

1953 Transferred to Arklow, Co. Wexford

1954 His mother dies

1955 Goes on painting holiday to St Ives, Cornwall

1956 Transferred to New Ross, Co. Wexford

1957 Goes on second trip to St Ives

1958 Retires from bank due to ill health. Brother Matty dies of a heart attack

1960 Departs for St Ives. Lodges with the Redgraves

1961 Has a heart attack. First St Ives exhibition at the Sail Loft gallery

1962 Moves to Trevaylor near Gulval. Shows at the Rawinsky Gallery, London

1964 Death of Peter Lanyon

1966 Moves into Penzance

1967 Moves back to St Ives into the Ship Studio. First return visit to Ireland

1969	Moves to Seal Cottage
1970	Meets the Canadian artist Jane Harris. Visits Clare Island and produces a significant series of drawings. Has operation on cancerous toe
1973	Marries Jane, has lengthy honeymoon in Switzerland
1975	Deaths of Wynter, Hilton and Hepworth
1974-87	Winter visits to the Bahamas
1975	Travelling exhibition organised by South West Arts and the Arts Council of Northern Ireland
1977	Buys cottage in Physicianstown near his birthplace. Begins to exhibit more frequently in Dublin. Another serious heart attack
1979	Large exhibition at the Penwith Gallery, St Ives
1981	Elected member of Aosdana. Irish Arts Council exhibition 'Miles Apart' opens in Kilkenny. Awarded Douglas Hyde Gold Medal
1982	Subject of RTE telvision documentary 'Places Apart'
1984	Large retrospective at the Ulster Museum, Belfast; Douglas Hyde Gallery, Dublin and Crawford Gallery, Cork
1985	Solo show at the Salt House Gallery, St Ives. Included in the Tate, London exhibition 'St Ives 1939-1964'
1990	Returns to Ireland permanently
1992	Exhibition of work from the 1960s tours Ireland
1993	President Mary Robinson confers the artist with the title of Saoi. Made an honorary member of the Penwith Society of Artists
1994	Receives an honorary doctorate from Trinity College, Dublin
1996	Large illustrated book of essays published jointly by Scolar Press and Butler Galleries
1998	Major exhibition at the Royal Hibernian Academy Gallery, Dublin
2000	Receives the freedom of the city of Kilkenny
2002	Fifty years retrospective of works on paper at the Taylor Galleries, Dublin. Recent graphic work, with Jane, at the Graphic Studio Dublin. Makes his last marks on a canvas on Christmas day
2003	Dies at home in Physicianstown on January 20

Laynon Quoit with Ding Dong mine

Nanven, Cot Valley

FURTHER READING

Brown, D. (ed.) *St Ives: 1939-64. 25 years of Painting, Sculpture and Pottery.* Tate Gallery rev. ed. 1996

Cooper, E. *Bernard Leach: Life and Work.* Yale 2003

Fallon, B. *Tony O'Malley: Painter in Exile.* Irish Arts Council and Arts Council of Northern Ireland 1984

Fallon, B. *Nancy Wynne-Jones.* Gandon Editions 2002

Gooding, M. *Patrick Heron.* Phaidon 1994

Graham, W. S. *New Collected Poems.* Faber 2004

Heron, P. *The Changing Forms of Art.* Routledge 1955

Heron, P. (intro.) *Tony O'Malley.* Arts Council Catalogue 1975

House, H. (ed.) *The Journals and Papers of Gerard Manley Hopkins.* OUP 1959

Lanyon, A. *Peter Lanyon 1918-1964.* Ltd edition privately printed, Penzance 1990

Lynch, B. (ed.) *Tony O'Malley.* New Island Books 3rd ed. 2004

Michiaki, K. *The Concept of Shibui.* Japan Quarterly. January/March 1961

Noall, C. *The Book of St Ives.* Barracuda Books 1977

Nolan, W. and Whelan, K. (ed.) *Kilkenny: History and Society.* Geography Publications 1990

O'Driscoll, D. (intro.) *50 Years: a Selective Retrospective of works on Paper.* Taylor Galleries 2002

O'Regan, J. *Tony O'Malley.* Gandon Editions 1994

Snow, M. and M. *The Nightfisherman: Selected letters of W. S. Graham.* Carcanet 1999

Stephens, C. *Bryan Wynter.* Tate Gallery 1999

Stephens, C. *Peter Lanyon.* 21 Publishing 2000

Suzuki, D. T. *Sengai: the Zen Master.* Faber 1971

Thiessen, G. E. *Theology and Modern Irish Art.* Columba Press 1999

Whittaker, D. *Zawn Lens: Words and Images from West Cornwall.* Wavestone Press 2003

Yanagi, S. *The Unknown Craftsman: a Japanese Insight into Beauty.* Kodansha International 1972

Singing Thrush 1973 10 x 7 in. ink on paper